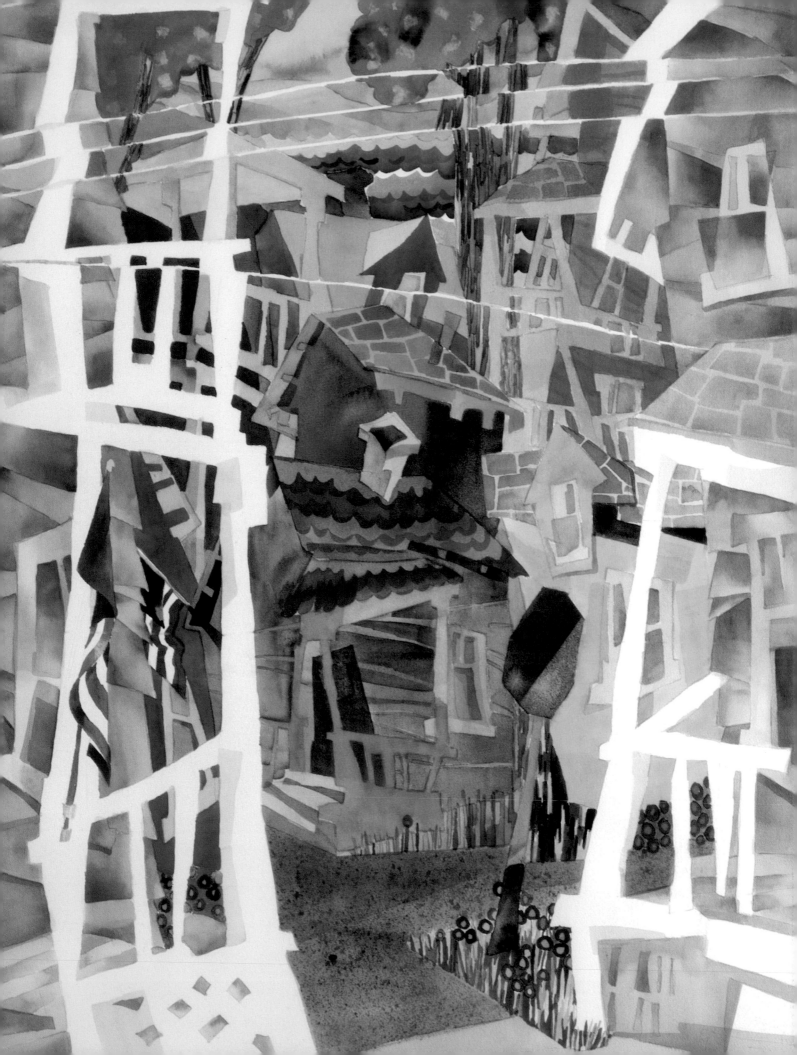

MASTER DISASTER

Five Ways to Rescue Desperate Watercolors

SUSAN WEBB TREGAY

NORTH LIGHT BOOKS
CINCINNATI, OHIO
www.artistsnetwork.com

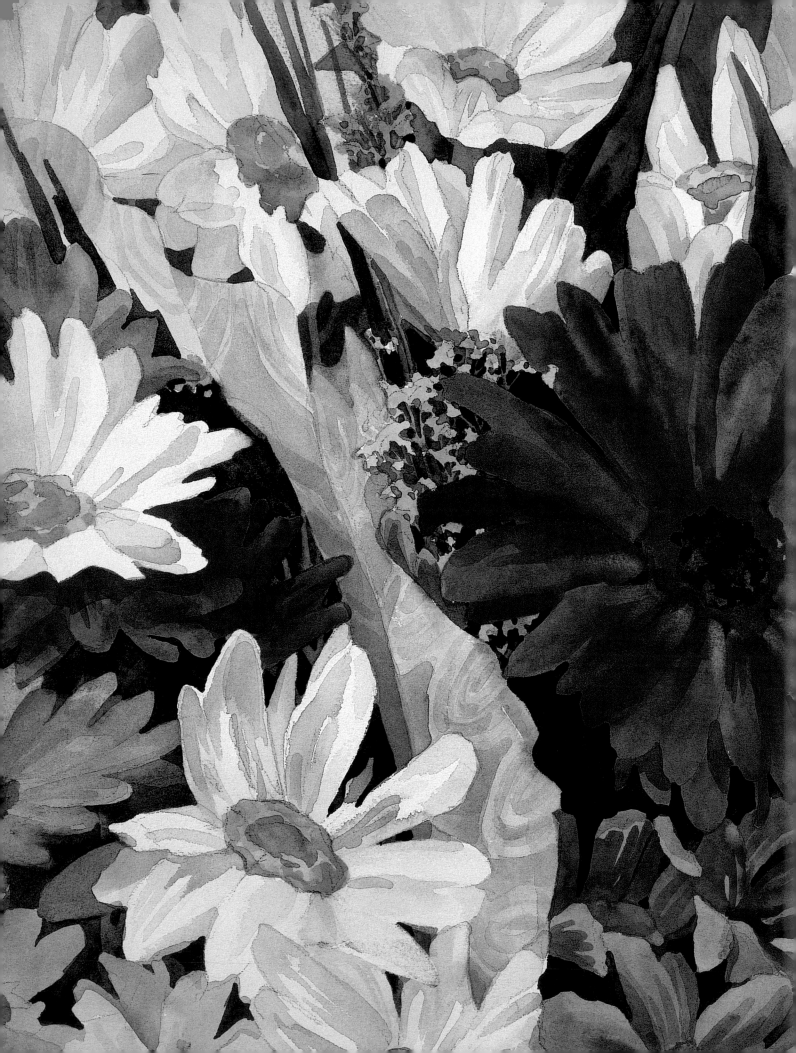

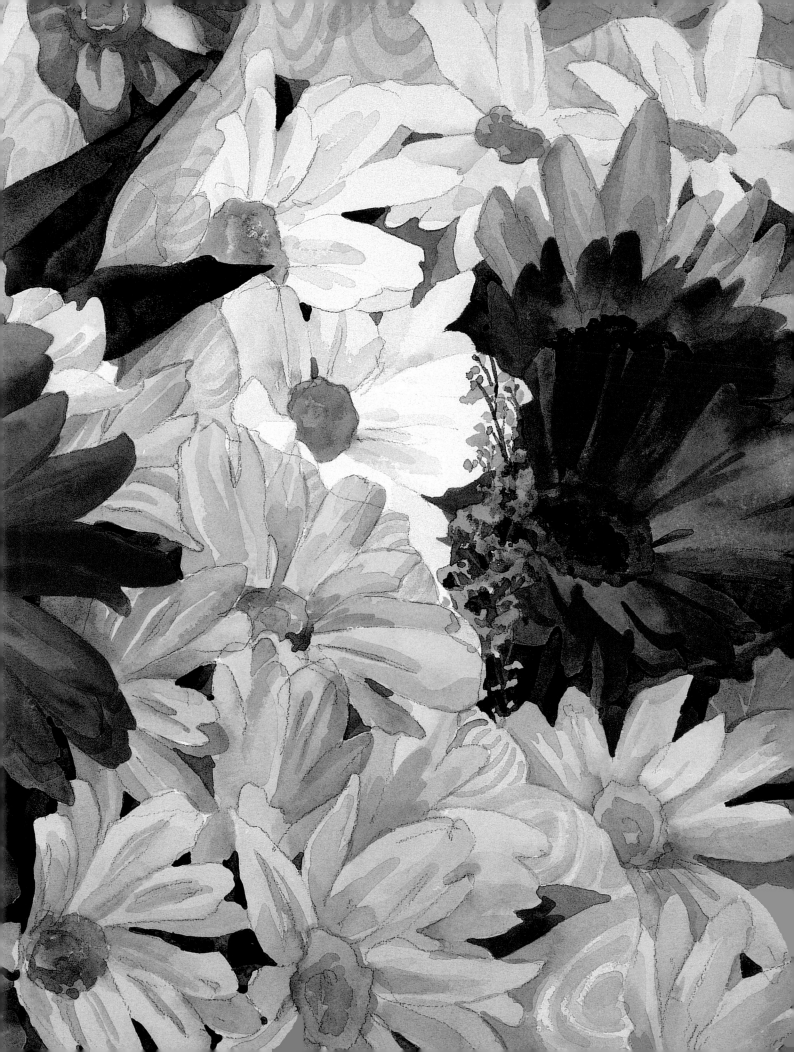

On page 2:
THE GRASS IS ALWAYS GREENER : *30" × 22" (76cm × 56cm)*

On page 4:
PARISIAN BOUQUETS : *22" × 30" (56cm × 76cm)*

Dedication

For George, of course, my husband and best friend, and for our kids, Sarah and Steve, who tiptoed around paintings on our living room floor for years—and became my best critics.

Other fine North Light Books are available from your local bookstore, art supply store or direct from the publisher.

11 10 09 08 07 5 4 3 2 1

DISTRIBUTED IN CANADA BY FRASER DIRECT
100 Armstrong Avenue
Georgetown, ON, Canada L7G 5S4
Tel: (905) 877-4411

DISTRIBUTED IN THE U.K. AND EUROPE BY DAVID & CHARLES
Brunel House, Newton Abbot, Devon, TQ12 4PU, England
Tel: (+44) 1626 323200, Fax: (+44) 1626 323319
Email: mail@davidandcharles.co.uk

DISTRIBUTED IN AUSTRALIA BY CAPRICORN LINK
P.O. Box 704, S. Windsor NSW, 2756 Australia
Tel: (02) 4577-3555

Library of Congress Cataloging-in-Publication Data

Tregay, Susan Webb
Master disaster : 5 ways to rescue desperate paintings / Susan Webb Tregay. —1st ed.
 p. cm.
 Includes index.
 ISBN-13: 978-1-58180-795-0 (hardcover : alk. paper)
 ISBN-10: 1-58180-795-3 (hardcover: alk. paper)
 1. Watercolor painting—Technique. I. Title.
 ND2420.T737 2007
 751.42'2—dc22 2006024366

Edited by Erin Nevius and Vanessa Lyman
Designed by Wendy Dunning
Production art by Jessica Schultz
Production coordinated by Jennifer Wagner

METRIC CONVERSION CHART

To convert	to	multiply by
Inches	Centimeters	2.54
Centimeters	Inches	0.4
Feet	Centimeters	30.5
Centimeters	Feet	0.03
Yards	Meters	0.9
Meters	Yards	1.1
Pounds	Kilograms	0.45
Kilograms	Pounds	2.2
Ounces	Grams	28.3
Grams	Ounces	0.035

About the Author

Susan Webb Tregay struggles to keep her priorities in line. She is an artist. She paints, and she paints for herself at least as often as for her clients. Teaching allows her to meet wonderful people, and writing gives her a respite from painting now and then. But first and foremost, she is a painter.

Tregay, a signature member of the National Watercolor Society and the Transparent Watercolor Society of America, has exhibited in museums and galleries around the country and has won many awards over the years. Her work is included in numerous corporate and public collections, such as The Arches Paper Co. USA, Blue Cross Blue Shield Association and the Federal Reserve Bank.

Art critics have enjoyed her work, calling one piece "the world's first funk-art Valentine" in *The Buffalo News* and another " ... the comic relief department, a certain naive wackiness ... " in *The Los Angeles Times*.

With her public art projects including a full-sized buffalo for the "Herd About Buffalo" project, and a dinosaur for the Burpee Museum of Natural History project in Rockford, Illinois, Tregay has fun with her art.

Two degrees in education make Tregay a compelling and thorough workshop instructor who has taught around the United States, Puerto Rico and Canada. Her workshops teach artists how to find and follow their own paths and stress the importance of exploring the content of their lives through their art.

Tregay, now an art critic for a local newspaper, has written for many magazines throughout her career, covering both the practical and controversial issues surrounding painting.

Tregay's paintings can be found in numerous publications, such as *The Complete Best of Watercolor* (Rockport, 2000), *Exploring Color* by Nita Leland (North Light Books, 1998), *Painting Composition* (Rockport, 1998) and *The Best of Floral Painting* (North Light Books, 1998). Visit her online at www.tregay.com.

Acknowledgments

Thank you ...

- belatedly to Miss "Tombstone" Toomey, my sixth grade teacher, who taught me how to write. Or else! And to the inventors of spell-check, without whom this book would have been inconceivable.

- to Margaret M. Martin for her inspired and generous teaching.

- to the members of the Niagara Frontier Watercolor Society of Buffalo, New York, for introducing me to watercolor and educating me about it, and for their friendship.

- to my students for their love and humor. And a special thanks to the Buffalo contingency for showing up on Monday mornings for years—with only one snow day. And to the members of the Asociacion de Acuarelistas de Puerto Rico for their heartfelt artist's statements.

- to our Buffalo Lunch Bunch, my special artist friends, for inspiring, pushing and supporting me for years.

- to my dear friends on the Grapevine, our online support group, who inspired this book and much more. Through the Internet, they made the move to Rockford, Illinois, with me. For this I am eternally grateful.

- to the folks at North Light Books. To Jamie Markle who had such faith in me, and to my editors Vanessa Lyman and Erin Nevius for their patience, good humor and encouragement.

TABLE OF CONTENTS

STEP ONE
LIGHTEN UP 17

The Elements and the Principles of Design ▪ Elements and Principles: A Mix-and-Match ▪ Establish the Focal Point ▪ Using Stencils ▪ Losing the Spark ▪ Cure It or Kill It ▪ Correct With Stencils ▪ Working With Stencils ▪ Other Types of Corrections

STEP TWO
BREAK IT UP 37

Dividing Space for Variety ▪ Breaking Up Space Through Repetition ▪ Breaking Up Backgrounds With Borders ▪ Using Texture to Break Up Space ▪ All That Background...

STEP THREE
ENRICH IT 51

Different Value Plans ▪ Steps to Enriching Your Paintings ▪ Avoiding Mud: Transparent vs. Opaque Paints ▪ Darkening Your Values ▪ Adding Real Darks ▪ Darkening With Washes ▪ Enriching Your Shadows ▪ Ways of Enriching With Shadows ▪ Evaluating Your Darks

STEP FOUR
UNIFY IT 63

Exploring Design Strategies ▪ Unify It With Color ▪ Content and Color Choices ▪ Exploring Color Strategies ▪ Using Color to Convey Content ▪ Applying Your Color Strategy ▪ Organize Color With Large Washes ▪ A Unified Painting ...With a Surprise

STEP FIVE
SURPRISE US 93

What's the Surprise? ▪ Using Trompe l'Oeil to Fool the Eye ▪ Demonstration: Adding Conceptual Surprises ▪ When Potentially Wonderful Paintings Are Boring

AFTER THE PAINTING
EVALUATE IT 103

Checking Every Square Inch ▪ Working on Your Focal Point ▪ Warming Up a Cold Painting ▪ Compare, Compare, Compare ▪ What Judges Are Looking For

AFTER THE PAINTING
MOVE ON: IDEAS FOR GROWTH 115

"Jasper Johns" It ▪ Work in a Series ▪ Improve Yourself; Improve Your Painting ▪ Look for a Balance ▪ Write an Artist's Statement ▪ Uncharted Territories

MICHIGAN AVENUE GOLD : 30" × 22" (76cm × 56cm)

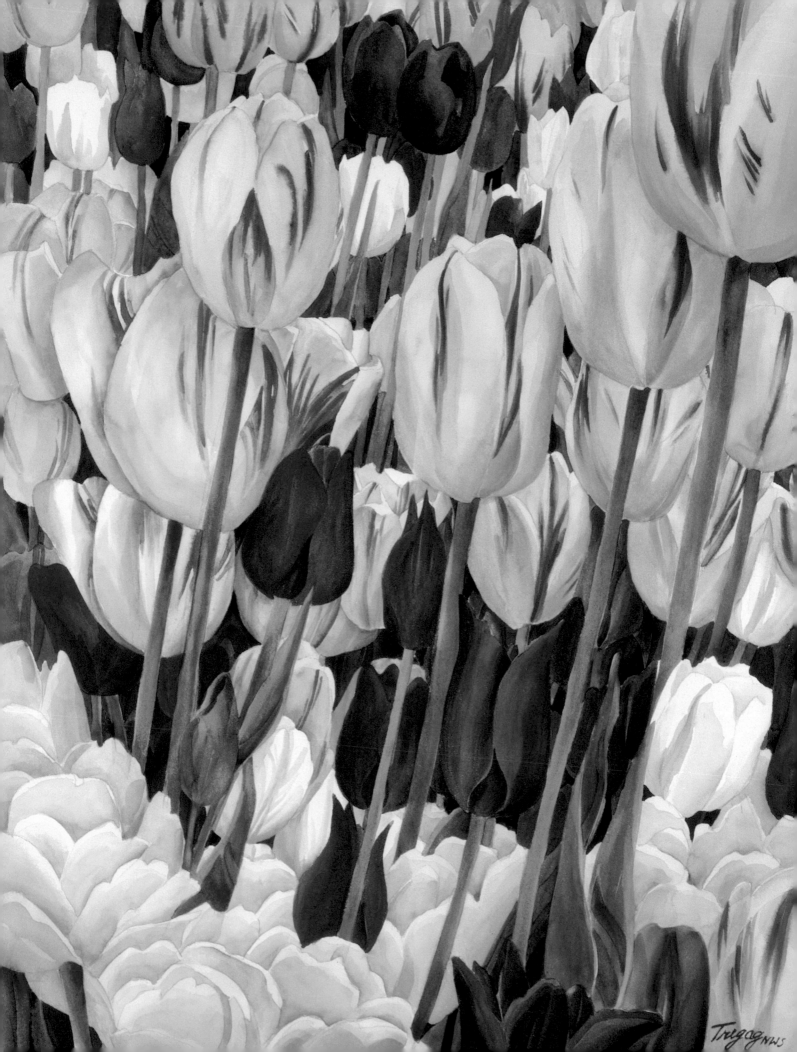

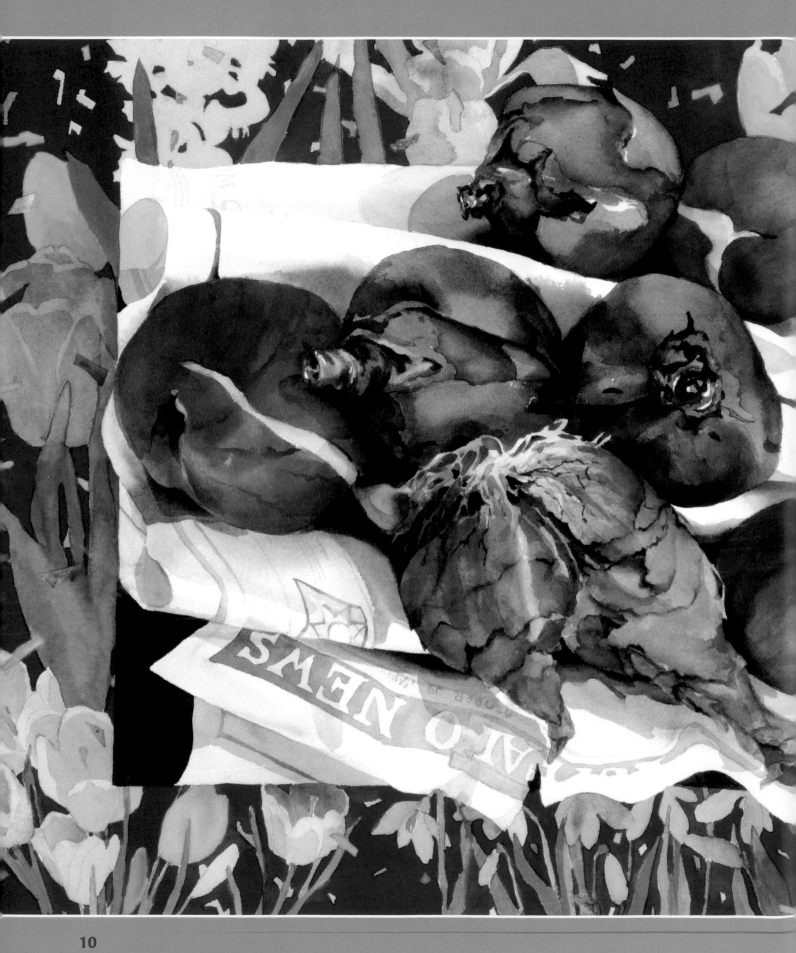

INTRODUCTION

Watercolor has a reputation for being both pretty and pretty difficult. Beautiful watercolor paintings struggle to be considered works of fine art, while at the same time the medium is ironically accused of being difficult and unforgiving. These excuses produce scores of half-finished paintings. You can take those beautiful starts, that pale painting hanging in your bathroom or the bombs stored under your bed, and turn them into finished, exhibition-quality pieces. It just takes courage. Well, courage and an understanding of content—putting yourself and your ideas into your work.

There are two reasons that this book is different from others on watercolor painting. First, I have learned that the detailed planning of a painting is not always desirable. Flexibility, rather than the perfect plan, is what makes finishing a painting possible. This book will allow you the freedom to be motivated by spontaneous washes of color and flashes of inspiration. Then you can step back, take the lessons from this book and polish a painting to completion. This book is your "Watercolor Home Repair Manual."

Second, I am not writing this to teach you how to paint like me. My purpose is to teach you how to finish your own paintings in your own style. You will learn how to paint like yourself—only better.

Students have told me that I've changed their lives. My workshop that inspired this book taught them to paint without fear of failure. "Kill it or cure it" became their motto, "No more wimpy watercolors" their war cry. Now it's your turn.

Painting is mostly about fixing paintings. Work your way through these five steps and complete your paintings with polish and pizzazz, then plan on returning to the first step and cycling through the routine once again. You are in for a wild ride or two, but I promise you will soon come out with the most satisfying painting of your career. I know this sounds like work, but it is very comforting to have a plan. Here is The Plan.

THEY'RE NOT ONIONS : *22" × 30" (76cm × 56cm)*

MASTER DISASTER IN A NUTSHELL

Fearless painting comes from flexibility. Knowing that you can experiment and correct areas of your paintings will free you to become the painter you always wanted to be. Here is a quick overview of the path that we will be taking toward mastering disaster.

STEP 1. First, we will lighten or remove whatever you hate about your painting. I normally use stencils to execute clean, precise corrections. You will draw the corrections right on your painting and cover the area with clear packing tape, masking film or contact paper, depending on your watercolor paper. Then simply cut a stencil in the shape of the area you want to change, and you can lighten or scrub it out. After blotting and drying the area, it can be freshly repainted.

STEP 2. Breaking up boring spaces is your next challenge. What will you do with all of that background?

STEP 3. Many, many watercolors are just too light. They don't photograph well, and they can't begin to compete with the gutsy paintings that you find in exhibitions. The third step to mastering disaster is enriching your painting.

STEP 4. Paintings need unity. Organizing your values and colors can pull a painting together at any stage of the game.

STEP 5. The last step is to surprise yourself and your viewers. Content is crucial to meaningful paintings, and it can be worked into your pieces at this late date.

I am truly excited to be able to take you on this journey. Come along with me, do the hard work (don't just read about it) and you will surprise yourself—but not me. I knew you could do it all along.

LET'S SING : 22" × 30" (76cm × 56cm)

WHAT YOU'LL NEED TO BEGIN

The supplies that you need to work with this book are both the same and very different from what's required by other books, workshops and teachers that you may have studied with. So this supply list is particularly important. Listen up!

Unorthodox Supplies

UNFINISHED PAINTINGS

First off, you need unfinished paintings. Bombs are best! We will be tackling them with gusto, so the less finished and more problematic the better. With a little imagination, these steps are helpful for work in any medium, so don't limit your bombs to watercolor. Acrylics and pastels can both prosper through these five steps to mastering a disaster.

STENCIL MATERIALS

You will need some sort of transparent film to create stencils for corrections, as well as a single-edged razor blade to do the cutting. The stencil material that you choose depends on the kind of paper you work on. Depending on your brand of paper, choose one of the following:

- For paintings on Arches paper or canvas, use 2-inch (5cm) clear, cheap packing tape. Cheap tape is lighter weight and easier to cut.

- For all other watercolor papers, as well as drawing and pastel papers, use clear contact paper or masking film, a clear film used by graphic designers and airbrush artists (available in art supply stores and catalogs).

If you don't know what brand of paper you're dealing with, you should either choose masking film or contact paper, or test packing tape in a corner of the work to see if it lifts off the top layer of paper.

Normal Supplies

You should always use your own favorite painting supplies. Don't be seduced into going out and buying my favorite brush or paint. As you have learned, there is no magic brush. Only guts and perseverance will make your paintings wonderful.

Every painter needs the following:
- pencils

- soft natural sponge

- paper towels and tissues

- a drawing board or piece of cardboard to clip your painting to so you can tip it at a slant

- large clips (called bulldog clips)

- clean water to lift watercolor, alcohol (91 percent) to lift acrylics and a soft gum eraser for pastels, charcoal and pencil

- coffee. This is your most important supply, as brewing a pot and enjoying a cup allows you the time to step back from your painting and get a fresh look.

PAPER

Stick with the watercolor paper that you know and like. Do be sure that you choose a stencil material that is appropriate for your paper, though: Packing tape will ruin some papers. Personally, I swear by Arches watercolor paper—both 140-lb. (300gsm) and 300-lb. (640gsm). This heavy paper allows for the use of packing-tape stencils and heavy scrubbing.

If you use several kinds of paper, be sure to check the watermark before using packing tape on it. If

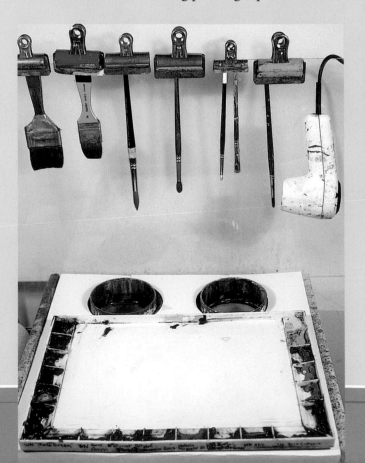

you tend to cut up different kinds of paper, write the brand name in the corner of each piece after cutting it so you will be able to make corrections with the right stencil material.

BRUSHES

While living in an apartment, I needed a backdrop for my taboret so I wouldn't splash paint on the walls, so I screwed a piece of Plexiglas onto the back of it. Later I discovered that I could clip my brushes to the Plexiglas. Not only was this handy, but they also could dry out straight, perfect and without having the water settle in their ferrules. (I could also find my clips!)

Repeat after me: There is no magic brush. There is absolutely nothing magic about my brushes. But if you need to purchase supplies or equipment, these are the ones that I use at this time:

- 2-inch (51mm) natural-hair flat (Grumbacher, very old and now held together with duct tape)

- 1½-inch (38mm) natural-hair flat (Isabey)

- no. 14 synthetic round (Loew-Cornell)

- no. 12 Kolinsky sable round (very old, with no point left)

- no. 4 fabric dye brush for scrubbing (Loew-Cornell)

- ¼-inch (6mm) old oil painting brush for scrubbing (bristles are trimmed to ¼-inch [6mm])

- no. 4 synthetic round (Grumbacher)

PALETTE

I work with a wide variety of paints: I am continually experimenting with new colors and brands. We will discuss paint characteristics throughout the book, but begin by working with whatever paints you normally use and enjoy.

If you need to buy paint, right now my palette consists of these colors. Basically, I keep warm and cool versions of each color on my palette. I always look for the most transparent versions of each color.

MY PALETTE

WARM COLORS

Permanent Lemon— *cool yellow (MaimeriBlu)*

New Gamboge—*warm yellow (Winsor & Newton)*

Golden Lake—*warm yellow, very strong and very transparent (MaimeriBlu)*

Raw Sienna—*used as a yellow, much more transparent than Yellow Ochre (Winsor & Newton)*

Brilliant Orange— *one of my two opaque colors (Holbein)*

Napthol Red—*warm red (M. Graham)*

Quinacridone Rose— *cool red (M. Graham)*

Alizarin Crimson Permanent—*primarily for mixing darks (Winsor & Newton)*

Quinacridone Burnt Orange *(Daniel Smith)*

Quinacridone Burnt Scarlet *(Daniel Smith)*

Burnt Sienna *(Winsor & Newton)*

COOL COLORS

Turquoise Blue— *my other opaque color (Holbein)*

Turquoise Green—*a very transparent version of Holbein's Turquoise Blue (MaimeriBlu)*

Thalo Green—*cool, primarily for mixing darks, doesn't run when re-wet (M. Graham)*

Sap Green—*warm and transparent (MaimeriBlu)*

Thalo Blue—*cool (M. Graham)*

Permanent Blue—*warm, very transparent version of Ultramarine Blue, discontinued (Winsor & Newton)*

Permanent Magenta— *warm (MaimeriBlu)*

Reddish Violet *(MaimeriBlu)*

Dioxazine Violet—*cool, great for mixing darks (Winsor & Newton)*

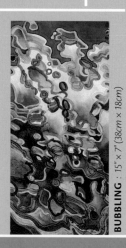

Playing With Reds and Yellows

BUBBLING : 15" × 7" (38cm × 18cm)

KATRINA : 15" × 4" (38cm × 10cm)

Exploring Blues and Greens

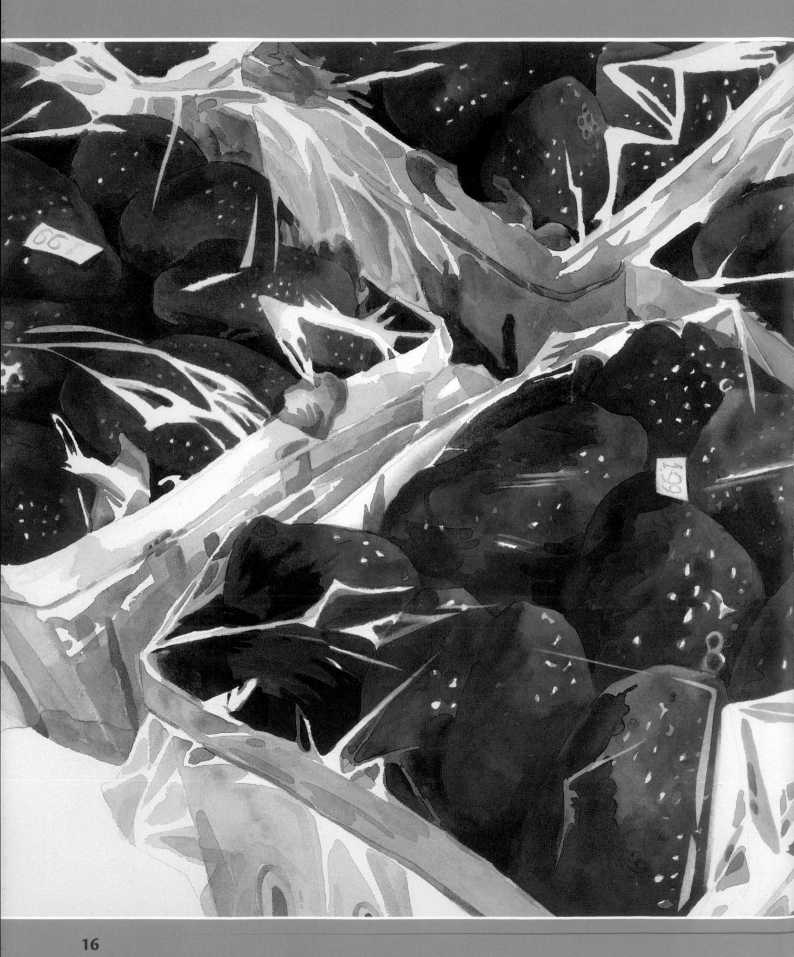

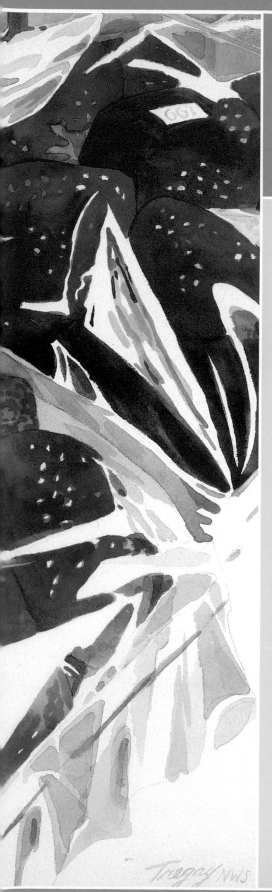

1 LIGHTEN UP

About two thirds of the way through a painting, we tend to get to the point that I fondly (or frustratedly) call the "ugly stage." You and I don't have to make do with parts of paintings that we hate, though. Step One to finishing your watercolors, Lighten Up, will show you how to lighten mistakes or get rid of them altogether. The secret is learning to cut stencils.

Frustrating drawing and painting errors and discouraging flat or muddy portions shouldn't be tolerated, but painting over them will only magnify the problem. However, simply keeping them will leave your painting weak and you discouraged. If you change to an opaque medium to cover them, though, you're just drawing an arrow that points out your mistake.

The best solution is to lift the problem out, dry the area and try again—and again, if necessary. Your persistence will pay off. By cleaning up your colors and adjusting your drawing, you are successfully coping with two elements of design—color and shape—and several principles of design. Use corrections to let your colors and shapes dominate and unify the painting, and the rest will fall into place.

PICKED AND PACKED : 30" × 22" (76cm × 56cm)

THE ELEMENTS AND PRINCIPLES OF DESIGN

The elements and principles of design are theories that have evolved throughout art history to describe what makes a painting "work." You can use them while composing a painting, but I find it easier to take advantage of them while finishing up. Let me formally introduce you to them.

To make the elements and principles of design work, you combine them and apply them to your painting.

The Elements

The elements of design are all nouns, things we can actually see most in our daily lives. *Lines*, *shapes*, *colors*, *sizes*, *textures* and *patterns*—these are common terms that are comfortable and ordinary, and they are also elements of design. For artists, *value*—another element—means the lightness or darkness of an object or an area.

Movement, another element of design, is often created through diagonal angles, sometimes called oblique angles.

The Principles

The principles of design can be thought of as verbs. Again, the first four are straightforward terms that you use frequently—*unify*, *vary*, *contrast* and *repeat*.

Grade is the verb form of the word gradation. For us it means to work in some gradual change to an element of design. For example, you can have an area go from light to dark (a gradation of value), from red to yellow (a gradation of hue) or maybe from big to little (a gradation of size).

Balance, another principle, is tricky to describe. Visualize a seesaw. If you have a large grown-up on one side of the seesaw, that person must sit near the center in order to balance several small children on the other side. So a large shape has visual weight. If placed near the center of the painting it can be balanced by small areas on the other side. Some colors and values seem heavy and others seem lighter. Your artistic judgement gets a workout when balancing your painting.

Dominate is one of the most important principles of design. One element of design, say line, needs to dominate over the others. That painting needs to shout "this painting is about lines!" There should be no doubt in the viewers' minds what your intentions are. Lines dominate this particular painting, or hot colors dominate that one.

Unify With Color
This paintings is unified—and dominated—by hot colors and angular shapes. These shapes create the movement in the piece. A bit of cool blue by the door contrasts with the rest of the painting and leads you into the focal point of this hot, hot painting.

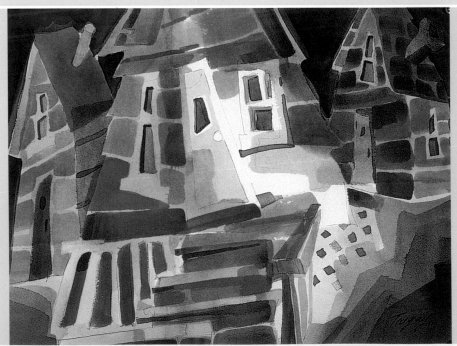

VERMILION STREET : 12" × 17" (30cm × 43cm)

When Lines Dominate

In *Sloop du Jour*, the linear patterns are the elements that dominate the painting. They repeat, are varied and fan out at contrasting angles. They unify the piece.

SLOOP DU JOUR : 22" × 30" (56cm × 76cm)

Unify With Simple Shapes

The shapes in *Sienna*—simple squares and rectangles—dominate and repeat throughout the painting. The warm earth tones also dominate. They are contrasted by the small amount of cool color of the sky.

SIENNA : 30" × 22" (76cm × 56cm)

ELEMENTS AND PRINCIPLES: A MIX-AND-MATCH

The seven elements of design and seven principles of design can become overwhelming when you consider that each relates to all of the others. This creates a very complex web of interactions. Instead of being overwhelmed, think of the design elements and principles chart as a mix-and-match. Pick one or two items from each column and concentrate on those things. Then life becomes much more manageable.

For instance, unity is essential to successful paintings. Limit your palette and pull your colors together. Unify your shapes into either angular ones or rounded ones. Or emphasize patterns or texture in a painting. These are ideas for unifying your painting. Using a variety of the design elements (size, shape, color, etc.), on the other hand, keeps a painting from being boring, while repetition of the same elements will unify a piece. Right now these elements and principles seem mind-boggling, but as we finish up your paintings, this information will begin to make sense.

This book will teach you how to get control of these elements and principles. It will teach you how to remove parts of your paintings that are inconsistent with the elements and principles you wish to be dominant. It will give you the confidence to unify your paintings with washes and the understanding necessary to balance the elements in your painting. You will learn to master disaster.

MIX and MATCH

The interactions of the elements and principles of design are the foundations of art. Each relates to all of the others. You don't need to worry about all of the possible combinations, though. Instead, choose one or two items from each column to play with and combine.

ELEMENTS OF DESIGN (NOUNS)

- **Line** (*can be straight, curvy or anything in between, made with a brush or any other tool*)
- **Shape** (*can be anything from angular to rounded, realistic to abstract*)
- **Value** (*light and dark*)
- **Color** (*can be realistic, abstract ... even emotional*)
- **Movement** (*the path a viewer's eye takes through a painting, primarily achieved with the use of diagonals in the design*)
- **Size** (*large, medium, small ... you get the picture*)
- **Texture/Pattern** (*textures tend to be rough or repeated small shapes, while patterns can decorate fabrics, wallpaper, etc.*)

PRINCIPLES OF DESIGN (VERBS)

- **Unify** (*to pull a painting together through the use of one or two of the elements*)
- **Contrast** (*to use dissimilar forms of an element together*)
- **Vary** (*to change an element, then use it with the original form*)
- **Repeat** (*duplicating an element*)
- **Grade** (*gradually changing from light to dark, from one color to another, etc.*)
- **Balance** (*like a seesaw, a large, light object can be visually balanced by a small, dark one*)
- **Dominate** (*one element that overpowers the others*)

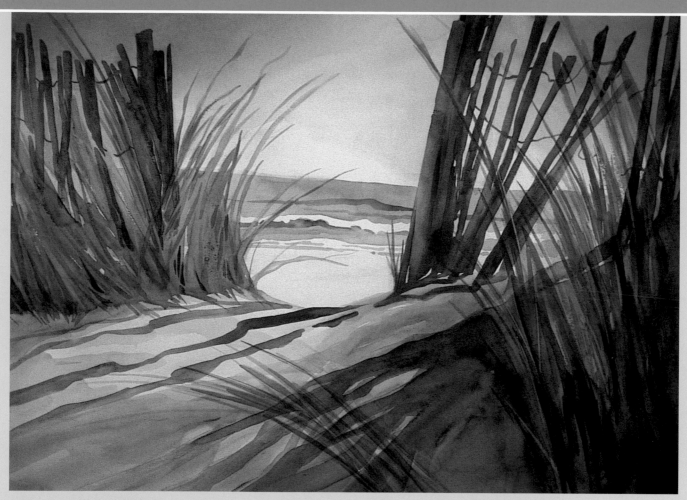

Movement Through Lines

Lines lead you into this painting and frame it as well. This work is more about movement through lines than it is about fences, shadows, grasses and sand.

MIX and MATCH

PRINCIPLES OF DESIGN	ELEMENTS OF DESIGN
Unify	Line
Contrast	Shape
Vary	Value
Repeat	Color
Grade	Movement
Balance	Size
Dominate	Texture/Pattern

FALL MARSH : *Mixed media* : *22" × 30" (56cm × 76cm)*

ESTABLISH THE FOCAL POINT

The success of your focal point is vital to the painting's success. By using the principles and elements of design, you can assure that the focal point is doing its job—attracting attention and delivering your message. There are seven ways to create a focal point. Some of these are widely used and others, such as texture, depend on the artist's personal style.

1. **Contrast of Value.** Putting your lightest light next to your darkest dark is the most common way of creating a focal point, because it's probably the most successful. The eye is immediately attracted to the contrast of light and dark. Knowing this, you should avoid placing intense value contrasts near the edges of your painting, where they are usually very distracting. Tone them down.

2. **Complementary Colors.** Colors that are across from each other on the color wheel, such as orange and blue, are a vibrant way to attract the eye to the focal point.

3. **Intense Color.** Red often shows up as a focal point. It's particularly successful in a muted or gray painting.

4. **Color Temperature.** A warm focal point in a cool painting, or vice versa, is inviting.

5. **Oblique Angles.** Diagonal shapes and lines leading into your painting are another way to heighten your focal point. Be careful that they don't point out of your painting, though.

6. **Texture.** Texture can be the focal point in a relatively smooth painting. You should avoid using strong texture elsewhere in areas that aren't your focal point. For example, in an otherwise smooth landscape, dry grasses along the bottom of your painting will fight your focal point for attention.

7. **Detail.** Realism is always compelling. Figures and words or letters will catch the eye in any work.

Other Focal Plans

We think of a focal point as just that—the point that is the main center of interest in a painting. However, many successful paintings have larger, compelling areas that serve as the focus. I refer to these as "focal areas."

Some paintings succeed by concentrating on a path of light or color for the eye to follow through the painting. I refer to this as a "focal path." This usually is a curved path of light, or it may consist of three or more small focal spots strung together like beads that lead into a strong, dynamic focal point near the painting's center.

Directing With Complements
Yellow and violet are wonderful complementary colors to direct your eye through a focal path or to a focal point.

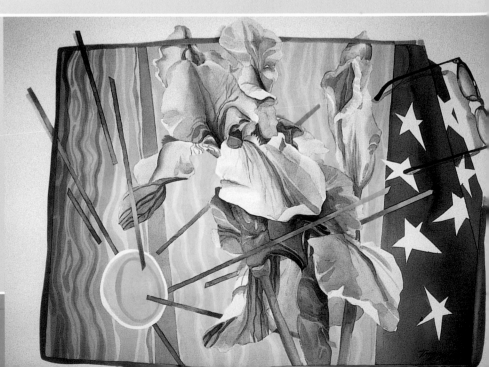

SUM, SUM, SUMMERTIME : 20" × 26" (50cm × 66cm)

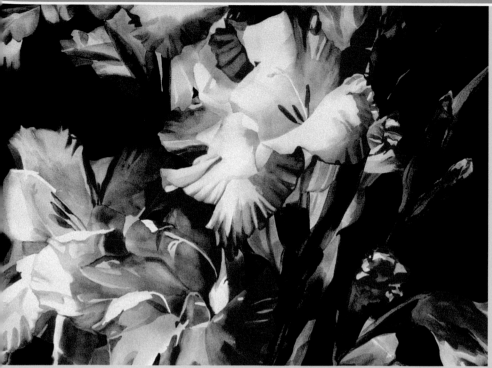

Using Several Approaches to Create a Focal Area

Shafts of Light uses three approaches to creating its focal area: 1. Contrast of value, with the intense white of the flower in the center of the dark painting; 2. Intense color of the highlights; and 3. Oblique angles through the use of diagonal patterns. Gladioli are such vertical flowers that it can be difficult to create movement within paintings of them. I had to take full advantage of every diagonal shadow and highlight to give the painting unusual movement and appeal.

SHAFTS OF LIGHT : 22" × 30" (56cm × 76cm)

Pulling the Viewer In

The focal point in *Michigan Avenue Bridge, Buffalo*, is created with two approaches: 1. Diagonal, oblique shapes leading across the bridge; and 2. A warm, red pattern on the truck in a very cool painting.

This extremely cold painting is typical of a Buffalo, New York, winter. It took very little red (and believe me, I tried a stronger one) on the truck to pull the viewer to it and across the bridge. You're also being pushed along by the diagonal road, shadows and bridge parts.

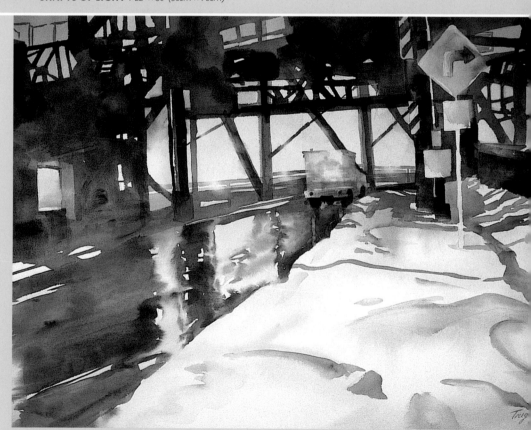

MICHIGAN AVENUE BRIDGE, BUFFALO : 22" × 30" (56cm × 76cm)

USING STENCILS

Being totally absorbed in creating your painting is a wonderful feeling, but eventually you need to evaluate and correct your work. We all make design mistakes; many of them gradually creep in while we're attending to other concerns, and others sometimes show up days later.

You don't have to tolerate things you don't like in your painting. If they're murky or poorly drawn, lighten or remove them, but do be selective. Don't throw the painting in the bathtub and scrub it all away. There's no need to start over if you have some wonderful parts of that painting and some feelings toward your subject. Instead, approach the problem parts of your painting one or two areas at a time. Eventually, you will get to them all.

What to Fix?

What's bothering you about your painting? What you want to do first is identify the problem. Once you know what it is, out it goes. These are some common problems that you should watch for that can be fixed with stencils: poorly drawn images, shapes that "kiss up," perspective problems, uninteresting shapes, lost highlights, forgotten items, and "mud" or flat, dull color.

POORLY DRAWN ELEMENTS

These might be as simple as flower stems that are too skinny to support the blooms. Make sure to do a reality check on things that are so basic they're easy to overlook.

If you're painting in a realistic manner, be careful to draw what you actually see—not what you may think the object should look like. (In these examples, I drew the pencil lines very dark to photograph well. Draw your own changes lightly.)

As children, we drew daisies with petals like the spokes of a wagon wheel, but few daisies are actually like that. The flower on the left is redrawn. With stencils, the offending tips of the petals can be removed and repainted to look more realistic and show more depth.

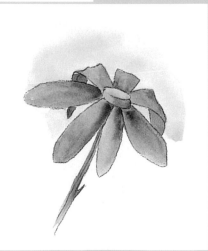

KISSING UP AND UNINTERESTING SHAPES

Important shapes that are just barely touching, or "kissing up" to each other, can create a tension that you may not want. Likewise, sometimes objects "kiss up" to an edge of your painting, creating the same uneasiness and drawing your viewer's attention out of the painting. In the first case, one object could be enlarged to overlap the other; in the second case, you might consider just enlarging the image and running it off the edge of the paper.

You also need to watch for uninteresting shapes. Shapes that are too similar become boring. Repetition has its place, but it's easy to overdo. Overlapping two shapes will create one more interesting element and spice things up.

The tulips on the left are guilty of both of these errors. They are identical shapes and are just barely touching each other. When the red tulip is enlarged as in the example on the right, both problems are solved. They now overlap, and together they make a much more interesting shape. Notice that the stem of the red tulip needed to be moved over to read correctly.

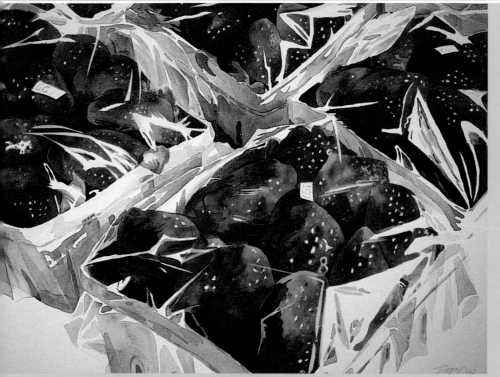

PICKED AND PACKED : 22" × 30" (56cm × 76cm)

LOST HIGHLIGHTS

Value contrast—so vital to a powerful painting—can easily slip from your control. Before you know it, light areas are lost beneath layers of paint, but you can gain them back. Check for lost highlights and other lost light areas.

Many of the highlights on the cellophane in *Picked and Packed* were lost—or ignored—during the painting process. Later I retrieved them by cutting stencils and scrubbing out lots of red paint.

PERSPECTIVE PROBLEMS

Perspective problems often don't become apparent until they are painted in. Perspective can become very complicated. A detailed study of perspective could make your work look like an architectural rendering, though. You probably want a more painterly look, and can get by with basic information.

The cover of the book on the left tips up from its realistic position. Paul Gauguin tipped his tabletops up on purpose, and this proved to be part of his genius. If this look doesn't fit your painting, though, figure out the correct perspective, draw it in and change it. The covers of books on the right lie flat now.

FORGOTTEN ITEMS

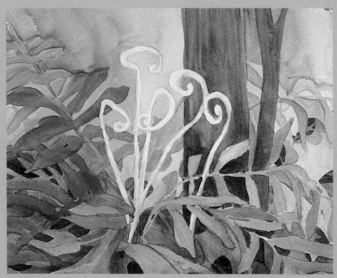

1 Forgotten Background
One of the most common mistakes that emerges during painting is forgetting to pass a color, or even an item, "behind" another item in the piece. In this watercolor sketch of fiddlehead ferns, I failed to pass my sky colors—turquoise and yellow—behind both the tree and the fern on the left.

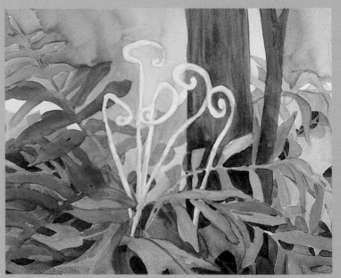

2 Lift Color
First, rather than removing all of the brown paint in these areas, I drew the scalloped pattern of the edge of oak leaves. Then I cut stencils protecting the fern, the tree and my new leaves, and scrubbed out the brown in areas that will become turquoise and yellow sky.

3 Repaint
Now my sky colors have been painted into the scrubbed areas. The turquoise now passes behind the fern, and yellow passes behind the tree, and I have created the illusion of more oak leaves. To see how this painting develops, turn to page 44.

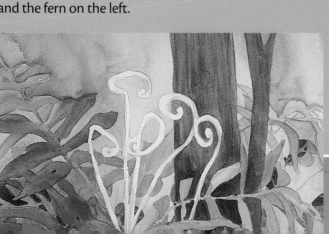

MUD

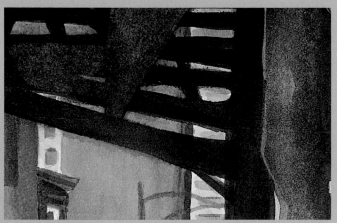

1 A Boring Spot

"Mud" and other colors that have lost their spark can really take the life out of a painting. Removing your "mud" and replacing it with a cleaner color will solve this problem. This detail shot shows part of Chicago's elevated train trestle, the "El." While I was developing the strong colors in the rest of the painting, this area got muddy and boring.

2 Lift Paint

First, I drew my corrections on the painting. Covering the area (and the surrounding area) with packing tape, I cut a stencil. Then I scrubbed out the support column on the right and a triangular area in the center. Just lifting the offending paint was enough to regain some control.

3 Repaint

Repainting these areas with the nicely transparent Dioxazine Violet and Quinacridone Burnt Sienna brightened the trestle without losing its dark, shadowed impression.

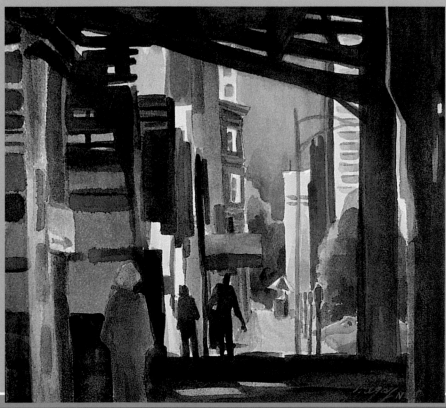

WALKING ON THE SUNNY SIDE : 12" × 12" (30cm × 30cm)

LOSING THE SPARK

Colors often lose their spark when certain opaque colors are mixed or layered with other transparent ones. After many layers, colors can become dull and flat, especially darks.

1 Dark, Flat Color
In this detail photo, the dark green foliage is nearly black in places—and very boring.

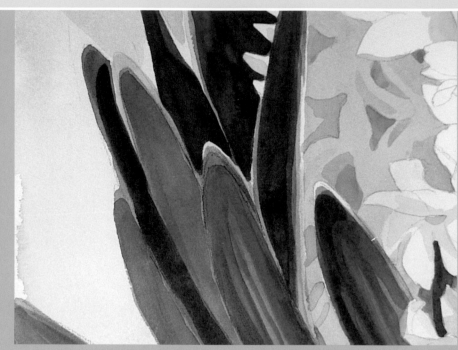

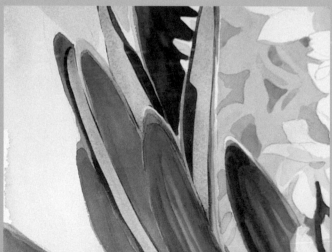

2 Lift Paint
You can see where I cut stencils and scrubbed out the offending dark green. Though these dark colors contained Thalo Green (an incredibly staining color), I was able to lift out plenty of the color to brighten the areas.

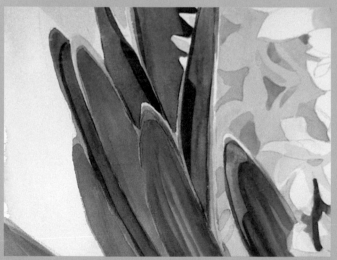

3 Repaint
Now the areas are repainted with lighter, fresh blues and greens (Holbein Turquoise Green and M. Graham Sap Green). You will be able to follow the development of this painting through the book with the final painting appearing on page 101.

All paintings start off with a great idea, but many of them succumb to the reality of boring areas or uncertain perspective. Cropping paintings may be the time-honored way of saving paintings, but we will only become better painters by challenging ourselves to finish them. Take this one, for example. This painting started off with a wonderful photo of flowers that had been sitting in a cart on a narrow street in Italy.

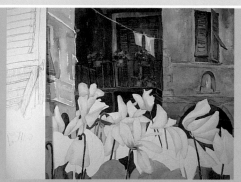

1 What to Improve?

While these flowers looked great in my photo, the cart they originally appeared in really didn't make sense in the painting. Could I put them in a window box instead? Would that improve the painting? The left edge of this painting was boring, so putting in some shutters would make that area more interesting and "frame" the painting as well.

2 Making Adjustments

First I drew a shutter on some sketch paper and tried it out on my painting.

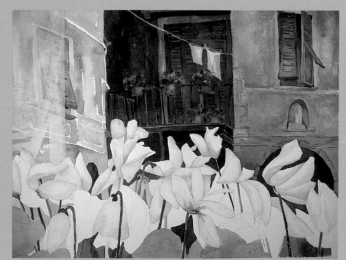

3 Drawing, Taping, Cutting, Scrubbing

As you will learn to do later in this chapter, I drew the shutter directly onto my painting, covered that side of my painting with clear packing tape (since I was working on Arches paper) and cut my stencil. Then I scrubbed out the area that will become my shutter.

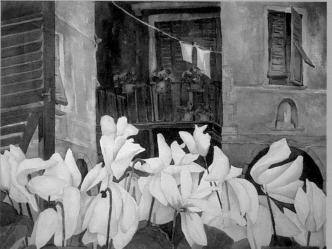

CAMOLI WINDOW BOX : 22" x 30" (56cm x 76cm)

4 Painting in the Solution

I removed the tape and dried the area, painting the shutter a deep green. Painting in a narrow band on the right also suggested the other shutter. They "framed" the painting and added interest while obscuring what might have become a perspective problem.

Crisp, clean corrections can be made with stencils. The simplicity of this useful technique—you draw and cut the stencil directly on your painting—will make stencils one of your crucial tools. Watercolor paper, especially Arches, is extremely tough and forgiving. You paid a lot of money for quality paper, so take advantage of it.

Stencil Materials

Clear, two-inch wide packing tape makes a wonderful stencil material for heavily-sized papers, such as Arches. Office supply stores sell this inexpensive, light-weight tape in packages of six rolls. The tape cuts with gentle pressure from a single-edged razor blade. To keep from losing either the razor blade or the end of the tape, I tuck the blade under the end of the tape after each use.

Other watercolor paper may be more delicate. For these softer papers, like Fabriano or Kilimanjaro, you will need contact paper, available at hardware stores, or masking film from an art supply store or catalog. No matter what type of watercolor paper you prefer, you will also need a very soft natural sponge.

Testing Your Paper

First, it is extremely important to find out what kind of paper you're working on—this will determine which stencil materials to use. Look for the watermark in the corner of your paper. What brand are you using? In the future, if you cut your paper into pieces, write the brand's name in the corner of each piece.

To test your paper and get a feel for cutting a stencil, lay the packing tape over a dry, painted area on a heavily-sized paper (like Arches), cut a hole in the tape and scrub the area. Peel back the tape and check to see if bits of paper have been picked up by it. With this combination of tape and paper, you should not see any lifting of your paper. This is your goal, of course.

Stencil Materials
Masking film, contact paper and lightweight packing tape cut easily with single-edged razor blades.

Packing Tape
Packing tape is great for stencils. This tape has strong adhesive that works wonderfully but can only be used on Arches paper and other heavily-sized watercolor papers.

Using a softer brand of paper, such as Kilimanjaro, once again lay the tape over a dry, painted area and scrub it. Now lift the tape and look to see if bits of paper are stuck to the tape. If it peels up a layer of the paper, it can be tragic. This is bound to happen if your paper is a bit damp. Do not use tape on more delicate papers. Use masking film or adhesive papers instead.

If you use many kinds of watercolor paper, always test the tape on a corner of the page before you start making corrections. Apply it, cut a hole in it, scrub out the paint there and blot it with a paper towel. See if it pulls up the surface of your paper when you remove it. Also check to see how much of your water runs under any of these materials when you scrub, and be ready to blot it up when you lift your stencil. This is a wonderful system, but, like most things, it has its limitations. Know what they are before you start working.

a PRIMER on PAPER

- **Hot-pressed paper** *is essentially pressed when damp and has a very smooth surface. Unfortunately, this surface is easy to rough up with tape and scrubbing. Proceed cautiously.*
- **Cold-pressed paper** *has a texture to it from the molds the paper is made in. Less expensive, machine-made papers are available that recreate this slight texture.*
- **Rough paper** *is similar to cold-pressed, but has a great deal of texture to it.*
- **Sizing** *is a type of glue that holds the fibers of the paper together. Heavily sized papers can take a lot more abuse than those with less sizing.*
- **Soft finished papers** *use less sizing on the surface and in processing. They feel softer than heavily sized papers with their hard surface finishes.*

Experiment with the different kinds of paper to see what you like and what suits your style. I only use Arches because I love using packing tape for my stencil corrections—it's inexpensive, readily available, has multiple uses and has no frustrating backing that has to be removed every time.

Test Your Paper
Softer watercolor papers need gentler stencil materials such as clear contact paper, shown on the right, or masking film on the left. Notice that there is no lifting of paper bits. Masking film works beautifully. Contact paper works well, but water does seem to collect under it on occasion. Both of these stencil materials have backing paper that needs to be peeled off. I find this extra step frustrating, so I stick with Arches paper and packing tape.

Damaged Paper
Unfortunately, packing tape will damage the more delicate papers and most hot-pressed ones. Be sure to test tape on your particular paper.

WORKING WITH STENCILS

Now you are ready to get rid of anything you don't like in your painting. The problem with this sketch was muddy, flat color. The peels of the orange slices became gray when I tried to paint the shadow in those areas using a cool blue. Feeling that there must be a better way to paint them, I decided to get rid of the offending gray. There is also a dab of blue on the bottom of the middle slice that just shouldn't be there.

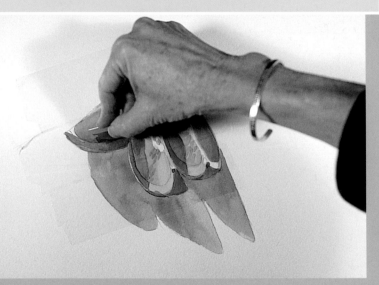

1 Apply Stencil Material and Cut Shape
Draw the correction directly onto the painting with a pencil, then cover the area with packing tape (or other material for more delicate papers). Cover the area generously. You don't want your sponge to accidentally drag over the outer edge of the stencil. Now you are ready to cut the stencil. With a single-edged razor blade, cut gently through the tape or film along the lines you drew.

As you cut through the stencil material, you will feel the texture of the paper slightly through your blade. You may even hear a gritty noise as the blade runs over the paper. This is the right pressure. Don't cut too deeply, of course.

2 Remove Stencil Shape
Using a corner of the razor blade, lift the cutout stencil shape in the area that needs to be cleaned up. This step can be difficult to see—you may want to experiment with the lights in your studio.

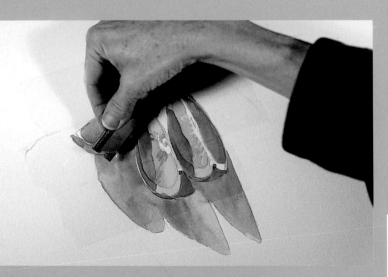

3 Lighten Paint With a Sponge

First, flush your sponge to make sure it's clean. Squeeze out any extra water and then scrub gently. Blot the area frequently with paper towels to pick up as much moisture as possible to keep it from seeping into the paper. If the paper gets damp on the inside, future corrections will be more problematic. Rinse your sponge and scrub the area again. If necessary, scrub hard.

Clean the sponge and repeat as many times as necessary, but don't remove any more paint than is essential. If you really want to get the white of your paper back, you can. Even the most stubborn colors will come out almost completely.

4 Remove Stencil Material

Blot the area again with a paper towel, then peel up the stencil material and blot underneath it one more time. Dry the area with a hair dryer; this will keep the next layer of paint from sinking deeply into the paper. If the scrubbed area is rough, burnish it down by rubbing it with the back of your fingernail. Cut lines don't show, so don't worry about them.

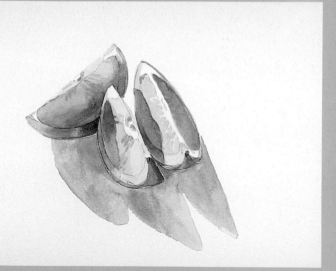

5 Repaint the Area

To repaint, choose a new color that is clear and refreshing. An unusual color, perhaps hot pink or orange, will add spark to small areas. Dark colors with a crisp, hard edge are perfect for freshening an adjoining, muddier area. I chose to repaint the orange peels with particularly clear, juicy colors (Quinacridone Burnt Sienna and Turquoise Green) to make them look freshly cut. If your repaint job doesn't look right, now or even much later, you may repeat these steps over and over with very little damage to good quality, tough watercolor papers.

OTHER TYPES OF CORRECTIONS

Sometimes you will want to have hard, crisp edges all the way around your correction. These are the cleanest and most successful. But other corrections may call for a smooth, softer transition between problem areas and their backgrounds.

Soft-Edged Corrections

At times, simple, soft-edged corrections are in order for a gentle highlight or to round an edge or to make it recede. For these you need a small bristle brush used for oil painting. Trim it to about ¼-inch (6mm). A "Fritch Scrubber" brush or a small fabric dye brush will also loosen and lift paint. Use clean water and blot frequently with paper towels when correcting this way. Unfortunately, these corrections usually look dirtier than the hard-edged ones made with stencils. Use bristle brushes sparingly.

Soft- and Hard-Edged Corrections

For corrections that need both a soft edge on one side and a hard, clean one on the other, use the following method:

Draw your correction on your painting and cover that area with your stencil material. Cut a stencil for the detailed side of your correction and peel away the side that needs softening or correcting. Use your sponge to wash away a gradual transition between areas. Blot and dry.

These soft- and hard-edged corrections are much cleaner and more successful than simply scrubbing with your sponge or bristle brush.

Changes in Large Areas

You can gently lift off or even flood away large areas of strong color with your natural sponge and clean water. Remember that there is no need to remove *all* of the paint.

Soften With a Bristle Brush
By softening the dark edge of this limb with a bristle brush, I made it look rounder and also pushed it back behind the apple blossoms. Turn to page 98 to see further changes to this painting.

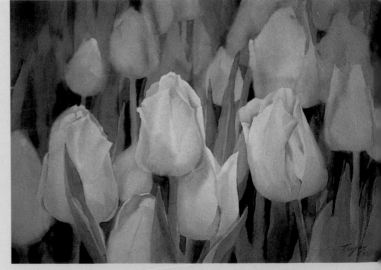

Creating a Soft- and Hard-Edged Correction
To establish the focal point in this painting, I wanted to have hard edges on the central tulips and soft edges on the outer tulips. I protected the central tulips in this painting with packing tape, then cut along the delicate edges. I left the tulips covered and lifted the rest of the tape. Finally, I gently softened the rest of the painting, first with a very soft sponge and clean water and then, when dry, with light washes of more color.

TULIP MYOPIA : *22" × 30" (56cm × 76cm)*

The trick to success here is to be sure to clip your painting to a support board. Then you must tip the board so that water flows off of the edge of the painting and into your wastebasket. In *Tulip Myopia*, I needed to hold the painting upside down and gently wash some of the paint toward what is actually the top edge of the painting. If you want a smooth look, you need to blot your paper with unembossed tissues. Dry the painting with your hair dryer before repainting.

Stencils With Other Media

If you are working in gouache (pronounced "goo-wash," gouache is essentially watercolor with white paint in it), pastel, acrylics or collage, stenciling can work for you, too. How you work with stencils may vary a little.

Cutting stencils to use with gouache is straight-forward. Because you can stir up layers of gouache when painting over an area, it pays to clean up the spot with a stencil and then rework it.

Pastel also profits from lifting extra layers. Instead of packing tape and a sponge, however, you'll need masking film and a kneaded rubber eraser. Lay your masking film gently on the work and cut the stencil. Patiently lift pastel with clean areas of the kneaded rubber eraser. You will get back to the tooth of your paper and be happier with subsequent applications.

To lighten acrylics, cut a stencil out of tape, then scrub the shape with a toothbrush dipped in rubbing alcohol (91% concentration). Blot frequently. This method will also add a lovely, burnished look to your piece.

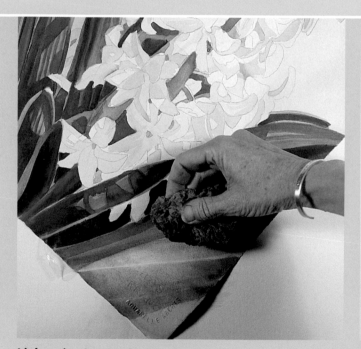

Lightening Larger Areas
The dark and boring lower corner of my hyacinth painting had to go. Laying the painting with its corner down on a slanted board, I washed away the offending paint. Turn to page 40 to see further changes to this painting.

VIEW FROM THE BACKSEAT : *Gouache and pencil* : 21" × 21" (53cm × 53cm)

Stencil and Gouache
When underlying layers of gouache muddied areas that I wanted bright, I simply cut stencils and removed some of the offending paint. Then I went on to finish the piece.

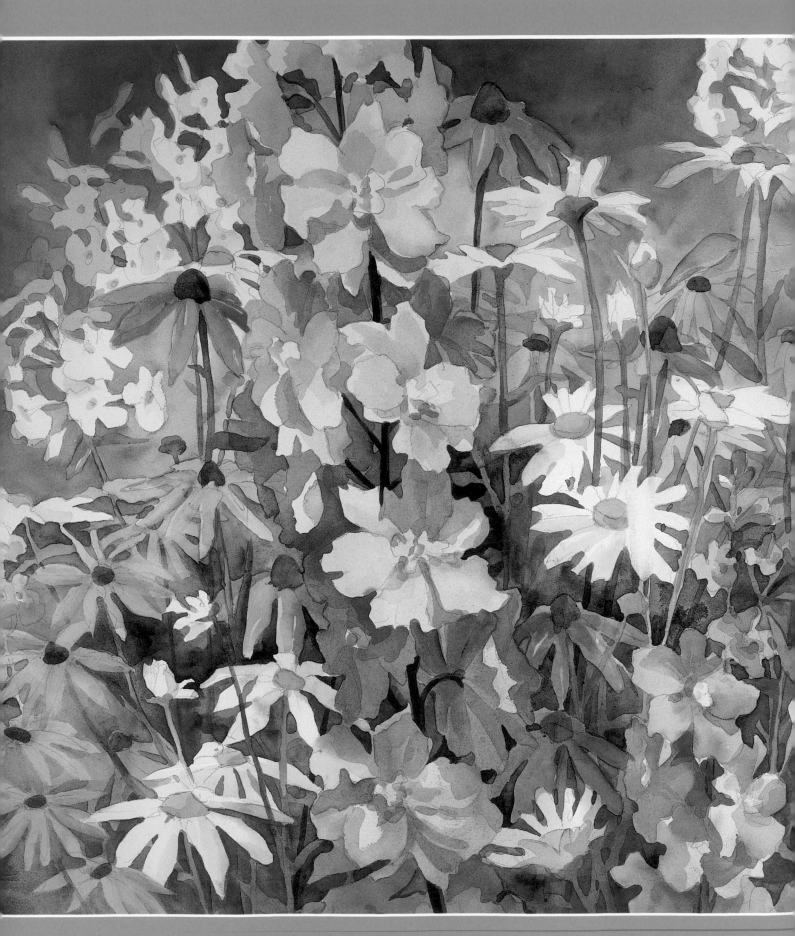

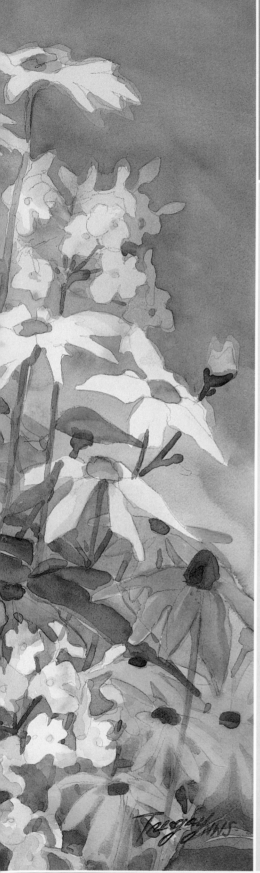

STEP 2 BREAK IT UP

The second step in creating a successful, beautiful painting is looking at it to see if there's enough going on in the work to make it visually interesting. We are routinely faced with a very simple background around our chosen subject matter. There might be a plain tablecloth, a gray street or a foreground copied from a photo that looks boring in the painting. Occasionally even our chosen subject matter has large, plain areas to deal with. These boring spaces need to be broken up and made more interesting. This chapter will show you how to vary and repeat elements in paintings to conquer these two principles of design.

You could activate simple areas with elements such as color, lines and different textures. But the easiest, cleanest solution to the boring-area problem is to divide spaces into pieces of various sizes, some realistic and some abstract. Overlap them or think of them as groups of three. But simply by breaking up space, your painting will look more complete, and you can confidently move it closer to the finish line.

AUGUST DIVERSITY : 22" × 30" (56cm × 76cm)

DIVIDING SPACE FOR VARIETY

First, check your painting for variety. Do you have an array of different sizes and shapes? You probably want large, medium and small shapes in your work—Papa Bear, Mama Bear and Baby Bear sizes. For instance, if all the blossoms in a flower painting are the same size, join two or three together to make larger, more varied shapes with unusual edges. You might need to divide a very large blossom and make it two smaller, overlapping ones instead. Are your trees all the same diameter and in a straight line? Adding a couple of smaller trees that lean slightly will give you variety. Simply draw in your changes, and, if necessary, cut a stencil, scrub, blot, remove the stencil and dry. Then paint in your changes.

SUNNY SIDE UP : 22" × 30" (56cm × 76cm)

Using Details to Break Up Space
Study your reference carefully, and you will see subtle details that you can use to break up space. In *Sunny Side Up*, the veins of the leaves look like a promising way to add interest. Rather than painting the veins with lines, however, I darkened the areas between them. This not only gives them a richer color, but also breaks up the large, plain leaf areas.

Use Shadows to Break Up Space
Barbizon, France, was home to an art movement in the mid-1800s. Considered to have sown the seeds of modernism, these artists were the forerunners of the Impressionists.

 This street scene in Barbizon was invigorated by shadows of imaginary houses on the other side of the street. Even a plain area on the wall was made interesting with the shadow of an imaginary lamppost. This type of shadow makes firm foundations for street scenes and landscape paintings and need not be cast by anything in particular.

IMAGINARY SHADOWS : 30" × 22" (76cm × 56cm)

Breaking up the Background

Are your sky and other background pieces different sizes and interesting shapes? If not, you should strategically run branches or other things off the edge of the painting to break it up. A practical reason to do this is that it cuts the sky, or other large areas, into smaller, more manageable sections to paint.

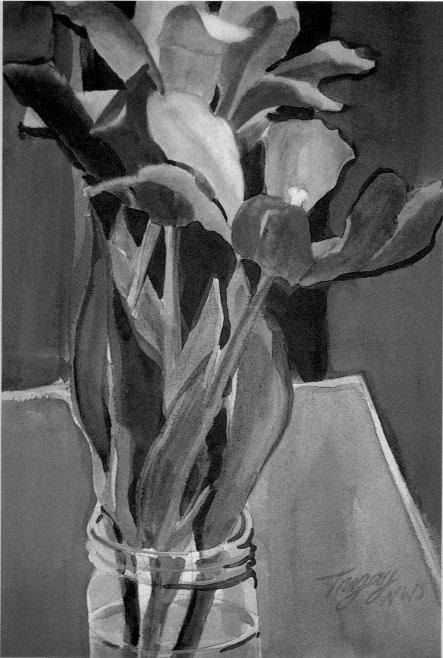

THE LIFE CYCLE : 20″ × 15″ (51cm × 38cm)

Dividing Space Abstractly

In *The Life Cycle*, the shape of these tulips became more interesting as the days went by. By extending the petals to the edge of the painting and dividing the rest of the space geometrically, I made the background almost as interesting as my topic.

BREAKING UP SPACE THROUGH REPETITION

Repeating objects throughout a painting conveys a feeling of abundance and activity. If you are given a few flowers, you can twist them and turn them, repeating them and making them into a huge bouquet or whole field of blossoms! Why would you want to do this? This is one way to add more paint to darken your painting, and a great way to activate boring background spaces.

AUGUST DIVERSITY : 22" x 30" (56cm x 76cm)

Adding More Blossoms

In *August Diversity* you can see that most of the yellow Black-eyed Susans were added later to fill in background areas. A few are painted directly, but many are developed by painting in the area *around* them with green. This is called negative painting. Creating this abundance of flowers from a photo of a very sparse garden both exaggerated reality and gave the painting a name.

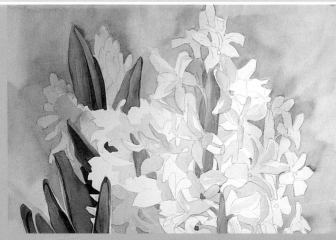

1 Using Repetition and Negative Painting
I decided to repeat blossoms in the mauve area at the top of my hyacinth painting. This breaks up the background space. After drawing more blossoms, I painted around them (negative painting) and continued the wash of paint off the paper.

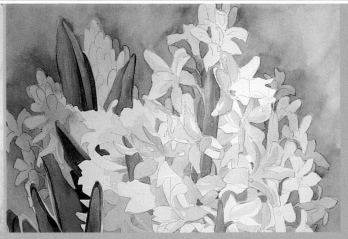

2 Add More Blossoms
With each wash of color, the blossoms get darker and recede into the background. Look carefully and determine which blossoms were added through negative painting. Turn to page 46 to see further changes.

Negative Painting in Action

As you deepen the background color, you could develop more blossoms by negative painting, though it involves a little planning. Negative painting works best when you have an unbroken area of paint that needs to be fixed.

Draw in your new flowers, keeping your drawing as simple as possible, then paint *around* them with your background color, starting at the pencil edges and painting toward the edge of the paper. This negative painting will leave a lighter version of your drawn flowers to ease your viewer into the background and to activate a boring space.

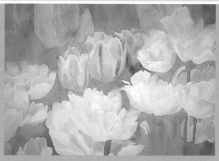

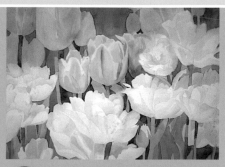

1 Lay the First Washes
After doing your basic drawing, lay washes of different pinks over the whole paper. When this dries, lay in some green areas at the bottom to begin defining the tulips.

2 Paint Directly
Directly paint the pink tulips (and some green areas around them) at the top of the painting.

3 Break Up the Background With Negative Painting
Create a dark green mixture with Thalo Blue Green Shade and various yellows. (Mixed greens are less harsh and more varied than tube greens.) Break up and darken the undeveloped areas of green using negative painting. Draw some tulip leaves, buds and stems. Paint the area behind them a darker green.

4 Finish with Negative and Direct Painting
Break up some more spaces along the top of the painting. Draw a layer of leaves. Paint around the leaf shapes to darken and then let dry. Then, in the same manner, draw another layer of leaves and paint around the shapes. Enrich some of the tulips with layers of paint and directly paint a few details.

ANGELICA TULIPS : 22" × 30" (56cm × 76cm)

41

BREAKING UP BACKGROUNDS WITH BORDERS

If you have a lot of extra space to deal with, consider putting in an interesting border. You could emphasize certain colors in the painting, develop a pattern that stylizes your topic or add objects that comment on your main thoughts. Objects in your painting can overlap the border to make it appear as though they're coming out of the painting. Your border can be irregular and funky, and adding one at this late stage is a reasonable choice—that way, you can coordinate it with the colors and tone of what's already there.

Working With Borders

Borders are a great way to add content and ideas to your painting. They allow you the space to contrast your topic with other thoughts, styles and techniques.

I planned the border of *They're Not Onions*. It gave me space to show that these were actually flower bulbs. It also gave me the chance to create a conflict between the realistic, three-dimensional treatment of the bulbs and the flat, contemporary style of the flowers. After I completed my stylized flowers, they still felt too realistic. So I sprinkled them with cut-up colored paper. This further flattened the floral images. Wanting this painting to be all transparent watercolor, I taped, cut stencils and scrubbed out all of the "confetti." Then I painted them back in. Using gouache or acrylic for the confetti can make it appear to float above the page. By finishing the painting with watercolor, I integrated the confetti into the page nicely.

One of the reasons I did *They're Not Onions* was to show a conflict between realism and stylized painting. Conflict in paintings is good because it puzzles your viewers and makes them think and spend time with your piece. Don't make your paintings an easy read. You don't want viewers to skim over them and move on to the next piece in the show.

DIRTY LAUNDRY : 30" × 22" (76cm × 56cm)

THEY'RE NOT ONIONS : 30" × 22" (76cm × 56cm)

Inventing Borders

The background in *Dirty Laundry* had been painted earlier, so I needed to tackle a border in a different way. I designed the border with stencils, scrubbing out color and adding new colors. I worked back and forth, scrubbing and repainting and scrubbing and repainting again until it finally felt right. The TV-like shape not only broke up the space, but gave a subtle talk-show flair to the piece. I blasted out the dots for texture with a dental water pic. Scrubbing out the ambiguous lettering felt right for the talking head.

Border With Interest

The inspiration behind this painting was learning for the first time that hyacinth bulbs were actually purple. So I bought a selection of bulbs and painted them. The result was boring. The border provided me the space to dream up what these bulbs would grow into next spring. The flowers were too realistic; I wanted them looking flattened and fantasized, so I drew in the "confetti" and cut dozens of stencils, lifted out the original paint and repainted them carefully. Now the flowers look the way I imagined them.

Improvising Borders

Here is a nice sketch of a neighbor's iris. Notice I said "nice," not "exciting" or even "fun." It's just ... nice. So I began to make it into a story about a hot spring day.

1 Defend the Border

You can see the shine of the packing tape used to protect the funky-shaped border. (This work is on Arches 140-lb. [300gsm] paper.) Planning a funky sun, I protected its rays with ¼-inch (6mm) striping tape from an automotive supply store.

Tape and other stencil materials make great paint-stoppers on unpainted paper. You can keep large areas of your paper pristine white while working right up to the edge and over the tape. Keep your shapes large, though. It's difficult and frustrating trying to work with tiny bits of tape. Also, this technique is not very successful on painted paper. Paint usually bleeds under the tape.

2 Utilize the Complements

After protecting the sun shape with packing tape, I painted heat waves on the left and a strong yellow behind the iris. Yellow makes the iris vibrate because of the complementary yellow/violet color combination. My idea for the flag impression on the right came as I worked on the rest of the background. Not all decisions need to be made from the start. I drew funky star shapes, covered the area with packing tape and cut them out, then removed the tape around them. After a few layers of rich blue, the flag came to life.

3 The Surprise Ending

Removing the tape from the sun and its rays, I painted the rays rainbow colors and the sun with a stylized ring. The sunglasses are a final surprise to the painting, and to me! After searching for the perfect finale to the painting, I decided on my sunglasses. I set them on a piece of paper in the sun and traced their shadow before a cloud moved in. After doing a practice painting, I cut stencils and scrubbed out where the glasses would cross the flag, and then painted the glasses in. Fun. Much more fun than the original iris sketch.

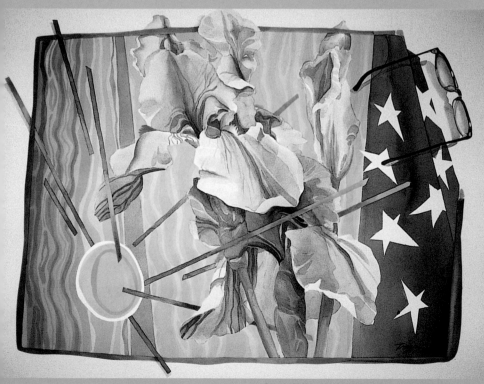

SUM, SUM, SUMMERTIME : 20" × 26" (51cm × 66cm)

USING TEXTURE TO BREAK UP SPACE

Texture is both an element of design and a way of creating a focal point. It's a simple, useful way to break up space. There are a few traditional ways to add texture, and as many innovative ones as there are painters.

Splattering

A traditional way of creating texture is to splatter some paint on your paper with a loaded brush for larger dots or running your thumb over a paint-loaded toothbrush for finer spatters.

This may be a good time to dip into your opaque paints, for light, vibrant colored dots will enliven your painting. I often use Holbein Turquoise, a very opaque pigment, or one of several opaque oranges to brighten up areas.

Drybrushing

Other traditional effects include drybrush painting. This technique involves a delicate balance between the amount of water and paint on your brush and the texture of your paper.

One type is done with a fairly dry, stiff brush. The brush is held vertically and whisked over the surface for grasses, tree leaves and such. For larger areas, you may wish to try another type of drybrushing. Load up a large, soft-bristled brush and then, holding it horizontally, drag lightly across the page.

Creating Texture Through Repetition

Start a collection of anything that might make great textures—it can be as simple as bubble wrap or corrugated cardboard. Generously apply thick paint to these surfaces with your brush and transfer the pattern to your paper. I like to use a roller to press the pattern down. Who knows: One of these items could become your signature mark.

Creating Textures With Stamps

Commercial stamps are readily available at craft stores today, and old printer's type sets of many sizes and styles can be found at flea markets and antique

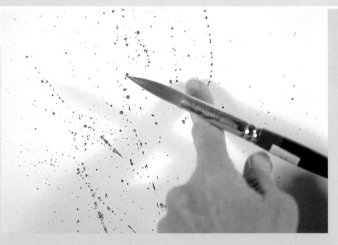

Splattering ▶
Load up your brush with fairly thick paint and gently tap it against your other hand. Don't be too aggressive about this, or your brush will whip paint back all over you.

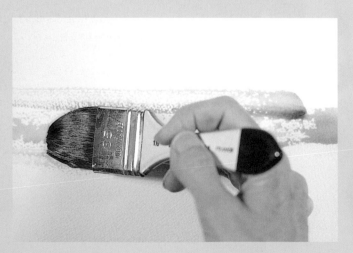

◄ Drybrushing Larger Areas
Load your brush with paint, squeeze out some of the excess and, holding the handle of the brush parallel and close to the paper, drag it along to create a rough look to the road or beach or whatever this turns out to be.

stores. Homemade ones are the best, though. Carve them into art gum erasers. Simply draw on the eraser. It carves very easily with your razor blade. Remember, the pattern will come out backward. Another pattern can be cut into the other side of the eraser. There are other materials for carving stamps available at craft stores, and any fairly thin, flat item or shape can be glued to a block of wood and used as a stamp. Start a stamping collection.

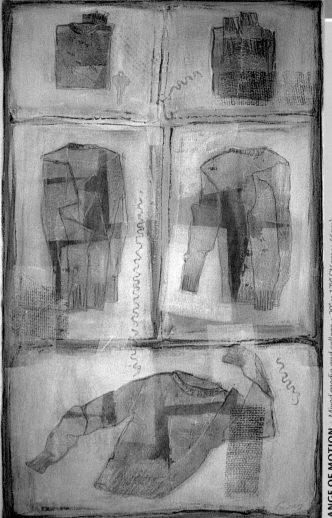

RANGE OF MOTION : Mixed media and collage : 29" × 17½" (74cm × 44cm)

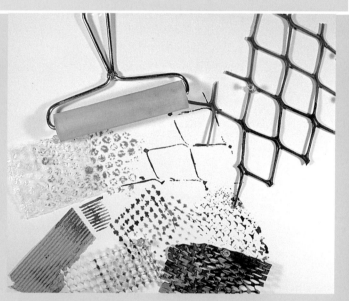

▲ Found materials
Starting from the top right and going clockwise, here are the elements I used to create these marks: plastic "snow" fencing, paper packing material, anti-slip matting for throw rugs, corrugated cardboard and bubble wrap. I ran the brayer (roller) across the back of these found items to transfer the paint to the paper.

▲ Using Texture to Create Meaning
In *Range of Motion*, the sweaters represent our lives unfolding. I glued a piece of a knit sweater to a board and stamped the texture on in three different places. But I needed one more element, as well as another idea, to make the piece feel finished. Then a student suggested unraveling! It was the perfect idea and a simple stamp to create. I just glued an unraveled piece of yarn onto a board, inked it up with acrylics and stamped on a wonderful depth of meaning to the piece. Sometimes our lives unravel.

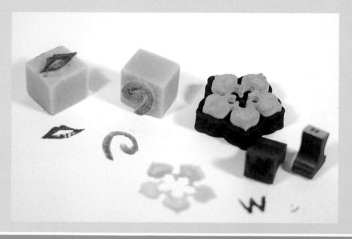

◄ Stamps
The stamps here include two carved from erasers, one purchased from an office supply store and two printers type stamps found at a flea market.

Lettering Supplies and the Marks They Make

Finally, letters and numbers can be used to create texture without necessarily saying anything. In fact, readable words in a painting can be distracting. Letters might give your piece the feel of a city, literature, commercialism or many other things.

Lettering can be created on your computer and traced onto your painting, or traced with commercial stencils. As I've mentioned, rubber stamps with letters on them can be found in hobby shops, toy stores and flea markets.

Vinyl stick-on letters, stars and other adhesive shapes can be applied to your painting and then painted over for subtle, negatively painted shapes and letters. On new paper, this technique will give you nice, clean letters. At this stage in your painting you can expect a textured edge on them. Start a stick-on collection, too.

Painting Patterns for Texture

Personally, I prefer to break up space with small, repetitive shapes and patterns. Henri Matisse was a master of this, using oversized, loosely constructed patterns to make things come forward in the picture plane. Wallpaper, tablecloths and clothing fabrics are wonderful sources of excitement in paintings of interiors because they can provide opportunity for patterns. Floral patterns, stripes and checks can be used either realistically or "just because."

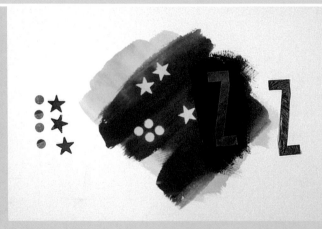

▲ Keeping Your Colors

The stick-on stars and dots were placed on a layer of yellow and burnished down, then washed over with red. When they were peeled up, they left behind yellow stars and dots. I added the letter Z to a red area and scrubbed over it with an oil painting bristle brush and Ultramarine Blue used straight out of the tube. All of the stick-ons were then removed and placed to the side.

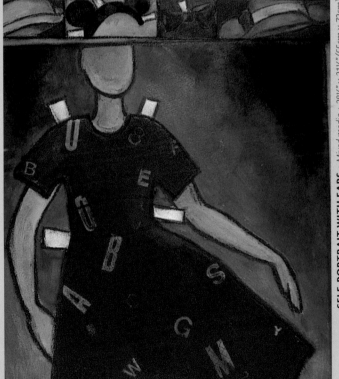

SELF-PORTRAIT WITH EARS · Mixed media · 28½" × 21½" (55cm × 72cm)

▲ Creating Patterns

Random letters create the pattern for this paper doll's dress. I applied vinyl letters over the original orange-red dress. Then, with a bristle brush, I scrubbed red watercolor paint straight out of the tube over the dress.

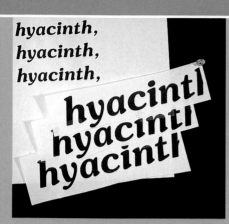

hyacinth,
hyacinth,
hyacinth,
hyacinth
hyacinth
hyacinth

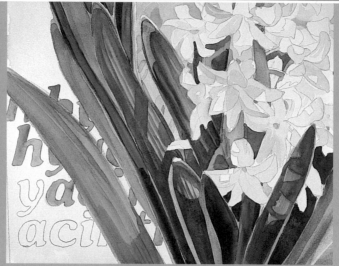

1 Tracing Letters

Because the name "hyacinth" is hard to remember and harder to spell, I decided to incorporate it into the background texture of this painting. I created the type on my computer and had to enlarge it more on a photocopier. Then the spacing between the lines was too large, so I trimmed the words and fit them closer together.

2 Adding Letters to the Background

Taping the words to my window, I positioned the painting over them and traced the letters. When painting them in at this stage, I don't worry about irregularities. I can always correct them, if necessary. This painting is continued on page 54.

This painting is continued on page 54.

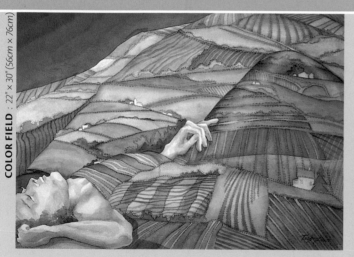

COLOR FIELD : 22" × 30" (56cm × 76cm)

◄ Patterns in Nature

This painting shows a quilt of patterns that flows over the knee and the hills of the sleeping giant, Rockford, Illinois. These patterns and colors actually exist in the farm fields of Illinois. Look for all sorts of patterns in nature.

► Adding Interest and Meaning

While my overall patterns forecast a busy day ahead for these dreamers, I squeezed content into painting by writing, stream-of-conscious style, my early morning thoughts as I struggle to get out of bed. Not wanting the viewer to stand there reading my disjointed, early-morning thoughts, I wrote every which way on the quilt.

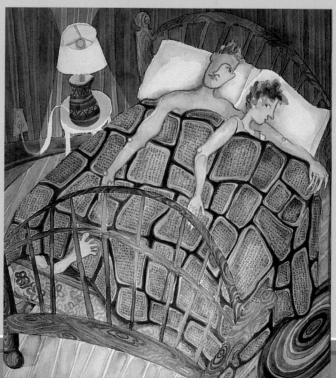

DREAMS ARE FASTER THAN DREAMERS : Mixed media : 20" × 18" (51cm × 46cm)

Toning Down Texture

If you sometimes find that the texture in your work is overwhelming your painting, you may be an artist who needs to evaluate your work for overbearing texture. If you use things such as salt or plastic wrap early in your paintings, now is the time to tone them down. Check your edges. Heavy texture along them will distract your viewer from your focal point. Tone down these edges, too.

◄ Softening Textures With a Wash
On the left are "stars" created with table salt on damp paint. The center textures were created with plastic wrap that had been crumpled, applied and weighted down with a book while it dried overnight. On the right is an example of coarse kosher salt applied heavily to damp paint, with other colors dropped into the salt. No matter how you create textures such as these, they need to be softened and toned down with one or two layers of washes, or they look very obvious.

◄ Making the Salt Patterns Mellow
There is heavy salt-created texture on the wall in this painting. Salt can look garish or cutesy, but when it is softened and mellowed with washes of paint, it takes on just the right character for the old walls of southern France.

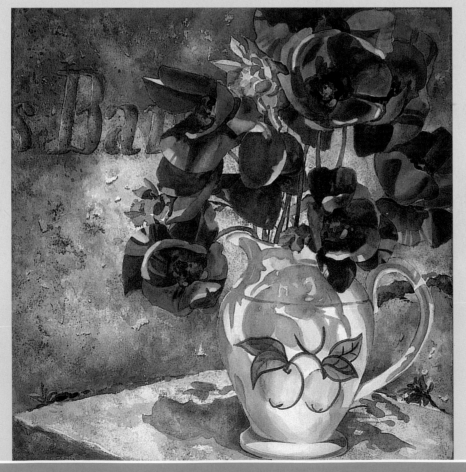

ALL THAT BACKGROUND...

The second inhibiting problem with finishing a painting is what to do with all that background. Don't rationalize the problem away. White or plain backgrounds rarely work, so break it up with additional shapes. By revisiting and resolving the size and diversity of the shapes in your painting, you will become much more comfortable with the piece, and it will be a more interesting, arresting work.

Two words of warning are necessary here: Whatever you do, don't add something that you are unfamiliar with, like a window, to the background just to fill up the space. It will look poorly drawn

and out of place every time. And avoid the trick of scratching your paper to create grasses. This damages the paper irreversibly. As you finish this book, you will realize that damaging the paper will make further corrections (and there will be several) impossible. You don't want to go down either of these paths.

Break up the space in your backgrounds, then break up the space in your large and boring foreground items, and you will have conquered the second major hurdle in finishing your work.

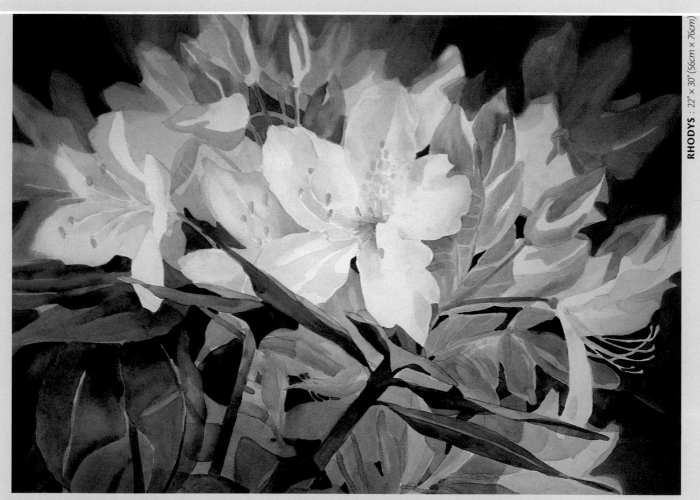

RHODYS : 22" x 30" (56cm x 76cm)

Add Background as You Go
Rhodys began with two or three white flowers, some leaves and a huge, plain pink and mauve background. I then drew all the colored flowers and painted the navy sky color around them. To avoid dealing with a large, dark and complicated wash, I touched the blossoms to the edge of the paper. This made those areas of small washes more manageable and the background easier to paint.

STEP 3 ENRICH IT

Watercolor has an age-old reputation for looking weak and pale. Paintings that use light, pastel colors, called "high-key" pieces, run the highest risk of appearing weak. Some can be wonderful and exciting, but many look washed out or unfinished. Watercolor doesn't have to succumb to this pale reputation, though—it can be used to create a full range of values. In painting, the term "value" refers to the relative lightness or darkness of a color. There are light and dark versions of all colors, even such absolutes as yellow and blue. Traditional paintings use a full range of values from the darkest black to the white of the paper. This step, Enrich It, will help you move your painting from simply pale to taking full advantage of the range of values that are open to all painters using any medium.

There are several reasons to choose to paint with a full-bodied range of values. First, light paintings are often considered sketches or look indecisive. Worse still, they are sometimes interpreted as incompetent. While we all have some measure of an inferiority complex, this book will push you past yours. By strengthening your colors, you can banish indecisive paintings and silence the critics.

Exhibitions are another reason to enrich your paintings. When a pale work is shown next to deep, brightly colored paintings, it looks simply wimpy. If it is exhibited with oils or acrylics, the problem is magnified. Oils and acrylics not only look brighter and darker, but they are not shown under glass. In poor lighting situations, watercolors have to fight for recognition with the reflections of their protective glass.

Finally, if you eventually want to exhibit in out-of-town shows, you will also need great slides. Light, pastel paintings are very difficult to photograph properly because, in order to capture the light colors, you may need to darken the whole slide. This often turns the light areas gray.

DIFFERENT VALUE PLANS

The three paintings on this page display different value strategies. *Daisies Galore* is a high key painting, lacking any really strong dark values. *The Tulip Clouds*, by contrast, has every value represented, from light to medium to dark, which makes it a full-value painting. *Block Party II* shows where contemporary color can take you.

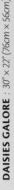

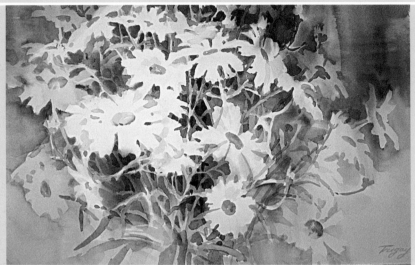

DAISIES GALORE : 30" x 22" (76cm x 56cm)

◄ What is a "High-Key" Painting?

This is a "high-key painting." It has no darks and very few midtones. I did this painting when I wanted to rescue this daisy plant from my garden before we had some work done on the patio. On such a busy day, I just had time for this sketch. As much as I love it, it would look washed out in a competition.

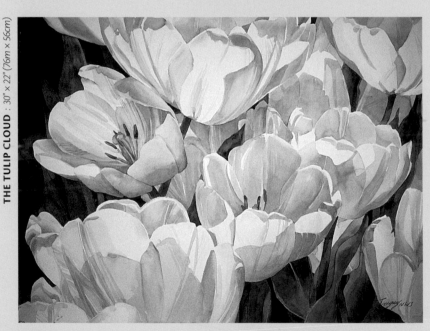

THE TULIP CLOUD : 30" x 22" (76m x 56cm)

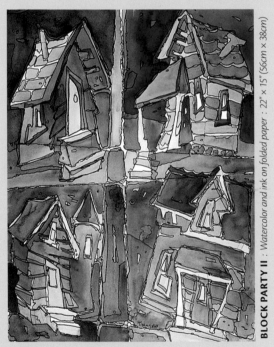

BLOCK PARTY II : *Watercolor and ink on folded paper* : 22" x 15" (56cm x 38cm)

▲ What Does a Full-Value Painting Look Like?

The Tulip Cloud is another large painting of white flowers. This painting, though, has a small amount of rich greens, navy and some black. Because it has a full range of values, the painting would assert itself in competitions, hang well next to oil or acrylic paintings and photograph better than a painting that only uses pale colors.

▲ Contemporary Color: How Is That Different?

Paintings that have very little change in value between their strong colors are usually called contemporary color paintings. Using little or no white or black, these colorful paintings are light-hearted and fun.

With a few exceptions, the values in this painting fall into the middle range—neither pastel nor extremely dark. It fits the definition of a contemporary color painting.

Steps to Enriching Your Paintings

Painting with gutsy colors is difficult for some people. If you have this problem, you are not alone. Take these small but decisive steps and intensify your paintings.

1. Fill Your Palette. Most importantly, you really need to allow yourself to fill your palette. Lots of people have little dots of paint lined up in the wells of their palettes. If this is the way yours looks, get your paints out and squirt an inch of paint along the back of each well. Let this dry overnight. You will find that you can pick up just the right amount of color on your brush without wasting any. Only the top layer of paint may become dirty, and this can easily be wiped off.

2. Develop the Intensity of Your Values. This step is very simple: Add two or more layers of similar colors to most of your painting. Second verse, same as the first. Many times you will need a third and fourth layer, too. Keep your new layers similar to earlier colors. This will keep your colors bright.

3. Keep Your Layers Colorful. When you add layers to your painting, you don't want to create that dreaded "mud." Mud is a color, usually gray, that has just gone dead and lost its spark. Avoiding these dead colors is easy: Paint with your most transparent colors first because these will never make mud. Use them as much as possible in the early layers of your painting.

4. Create a Color Chart to Prevent Mud. If you want to avoid making mud, you really need to make a color chart and find your transparent (and transparent staining) colors. To do this, staple a strip of black paper to a piece of your normal watercolor paper. Then generously load up your brush and swipe it across the black strip and onto your paper. Label each color with the brand of paint as well as its color name.

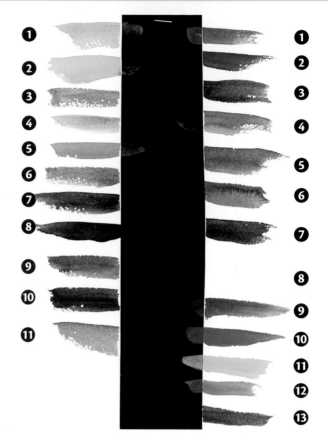

1	Permanent Lemon (MaimeriBlu)
2	New Gamboge (Winsor & Newton)
3	Golden Lake (MaimeriBlu)
4	Brilliant Orange (Holbein)
5	Quinacridone Coral (Daniel Smith)
6	Acra Crimson (Liquitex)
7	Permanent Alizarin (Winsor & Newton)
8	Primary Magenta (MaimeriBlu)
9	Red Violet (MaimeriBlu)
10	Burnt Sienna (Winsor & Newton)

1	Turquoise Blue (Holbein)
2	Turquoise Green (MaimeriBlu)
3	Thalo Green (Winsor & Newton)
4	Sap Green (MaimeriBlu)
5	Winsor Blue (Green Shade) (Winsor & Newton)
6	Permanent Blue (Winsor & Newton, discontinued)
7	Winsor Violet
8	Opaque Colors for Special Occasions
9	Cobalt Blue (M. Graham)
10	Cerulean Blue (M. Graham)
11	Cadmium Yellow (M. Graham)
12	Cadmium Orange (M. Graham)
13	Cadmium Red Light (M. Graham)

▲ Reading Your Color Chart

My palette consists of mostly transparent and transparent staining colors. They are the ones that disappear almost completely into the black paper. You will see that all yellows tend to show up slightly on the black strip. This is their nature. On my palette, I keep two opaque colors, Brilliant Orange and Turquoise Blue by Holbein. See how they stand out on the black strip. I save these for a special punch at the end of a painting. I keep all of the other opaque colors (on the bottom right of my chart) on a different palette so I won't be tempted to dip into them early in the game.

Avoiding Mud: Transparent and
Opaque Pigments

I find that, by avoiding opaque colors, I can mix and layer paint forever without getting mud. It's as simple as that. You have hundreds of transparent and transparent staining colors to choose from. You can live without the opaque ones.

Opaque colors can be used in a few circumstances, though. Try using your opaque favorites only over very similar colors. For instance, use Cadmium Red, an opaque-looking watercolor, with other yellows and oranges. There's no way to get mud from red and orange.

Making Mud

Yes, so-called "transparent watercolors" come in some very opaque shades. Mud comes from mixing and layering these with staining paints. Oftentimes, there are both transparent and opaque versions of the same color. Yellow Ochre, for instance, is a more opaque and more troublesome version of Raw Sienna, which is almost transparent. Use the transparent version of a color in the early stages of your painting. As you finish up, you can resort to

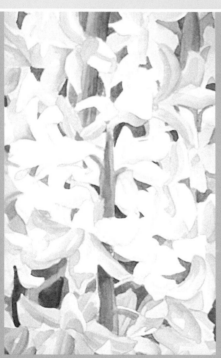

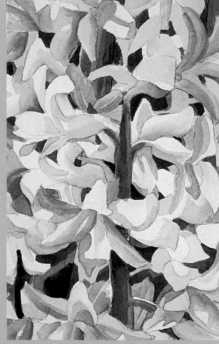

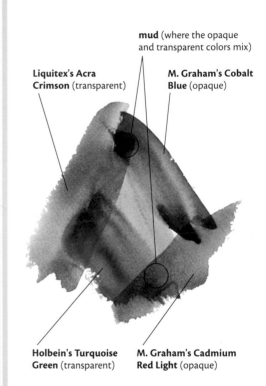

mud (where the opaque and transparent colors mix)

Liquitex's Acra Crimson (transparent)

M. Graham's Cobalt Blue (opaque)

Holbein's Turquoise Green (transparent)

M. Graham's Cadmium Red Light (opaque)

1 Too Light?
Returning to the hyacinth painting, the blossoms (although they were actually white), are still too light. They are dependent on my pencil drawing for definition.

2 Add More Layers
Through simple repetition of the original colors, the flowers are now richer and more three-dimensional. It's important that all parts of your paintings be "finished" to the same degree. Now my flowers are catching up to the foliage's finished appearance. This painting is continued on page 54.

an opaque paint if you want some extra sparkle or a heavier look.

When it comes to making mud, Ultramarine Blue can be a problem color. In some brands it's quite opaque and goes dull fast. If you use a lot of this blue—and get a lot of dull mixes—try another brand. Or learn to live without it.

Do you find that you have several opaque colors on your palette? Cover those wells with a piece of masking tape for the time being. That way, you can't accidentally use them before you get near the end of your painting.

◄ Avoiding Mud
The transparent colors in this test swatch are Golden Lake, Acra Crimson and Turquoise Green. Transparent colors behave beautifully with each other. When the opaque colors Cobalt Blue and Cadmium Red Light are added, we see the beginnings of some dead colors. This occurs when opaque and transparent (or transparent staining) are mixed or layered together.

It takes several layers of color to finish a painting. You run the risk of your work getting muddier and muddier as the layers pile on. Stick with transparent and transparent staining colors for now. They allow you to add multiple risk-free layers as your piece progresses.

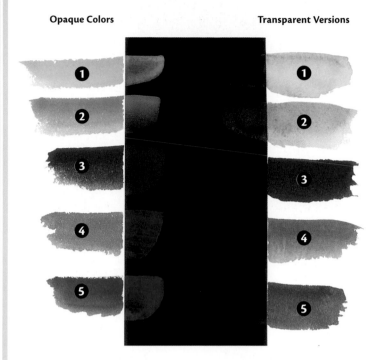

Opaque Colors Transparent Versions

Opaque Colors	Transparent Versions
1 **Cadmium Yellow** (M. Graham)	1 **New Gamboge** (Winsor & Newton)
2 **Yellow Ochre** (Winsor & Newton)	2 **Raw Sienna** (Winsor & Newton)
3 **Cadmium Red** (M. Graham)	3 **Napthol Red** (M. Graham)
4 **Turquoise Blue** (Holbein)	4 **Turquoise Green** (MaimeriBlu)
5 **Cobalt Blue** (M. Graham)	5 **Winsor Blue (Red Shade)** (Winsor & Newton)

▲ Similar Opaque and Transparent Colors
Many colors come in both transparent and opaque pigments; here are both versions of some of them.

◄ Distinguishing Transparent From Opaque
You can usually tell which colors are opaque simply by looking at them on your palette. My transparent Turquoise Green (on the right) and my opaque Turquoise Blue are virtually the same color when painted on paper. But look at them in the palette. The opaque one is light and the transparent one is very dark. Transparent colors straight out of the tube are dark!

Darkening Your Values

As you know, watercolor dries lighter than it appears when it is wet. Initially this is a troubling factor in every watercolor painting. Developing strong color is an issue that has to be revisited over and over again as your painting progresses.

Because watercolor dries about 20 percent lighter than when you painted it, creating a value strip with ten values will help you enrich your paintings with fewer layers.

Creating a Value Strip

To create your value strip, divide a strip of watercolor paper into ten 1-inch (26mm) segments. Mix up a large wash of very light gray. Leave your first space white and, starting with space number 2, paint the rest of the strip very light gray. Dry it with your hair dryer. Then, starting with space number 3, again paint the whole strip with your light gray. Space number 3 will go slightly darker, of course. Continue layering in washes until you get to the space 10.

Space 10 should be black, but you may find that your space 10 is not dark enough. You may need to then darken up the lower part of your scale and adjust the values as you go. Numbering the spaces and punching a hole in each space makes the value strip easier to use.

Mas Oscuro

There is an old joke about watercolor classes that says you can walk by any class and yell in the door "darker, darker," and you will have given the right instructions to everyone in the class. Teaching in Puerto Rico, I made a sign that said *Mas Oscuro* (Spanish for "more dark"). The class had a good laugh over both my sign and my pronunciation, but everyone's paintings came out full-bodied and beautiful. *Mas Oscuro*, everyone. Darker, darker.

◄ Know When It's Too Light
This early stage of my painting *Narcissus* (30" × 22" [76cm × 56cm]) (at left) shows little more than the tints and structure of my idea. If your work resembles this, don't be afraid to add more paint.

After applying several layers of basically the same colors, the painting (below) has become rich and vibrant.

◄ Using Your Value Strip
When you are enriching and darkening your painting, hold your strip over the wet paint and note its value (space number 8, in this example). Your paint will dry two steps lighter. On your scale of ten, that means it's drying 20 percent lighter. The red paint showing through space number 8 is wet, while the red area showing through space number 6—two spaces, or 20 percent, lighter—is dry.

Now, when you paint something, hold your gray strip over it and find its value. This will dry two values lighter. Will this be dark enough, or should you paint it stronger? If your paint looks dark enough when it is wet, it will dry too light every time!

Adding Real Darks

The easiest way to convince yourself that your painting needs stronger values is to put in some real darks. If you are working on a traditional painting, choose where you want your viewer to look first. This is your focal area or focal point. Now look for a reason to put in some real, gutsy darks next to a white or light spot in the area. Are there some bushes showing through that white fence? Is there an interesting shadow on the building? Could you open that front door and show a sliver of a dark interior? Could there be a deep shadow next to your primary flower? Paint your chosen area very dark. It could be navy, purple or another dark color or colors. It need not be black.

If your corrections from Step One, Lighten Up, are occurring in the focal area, you can now take advantage of your scrubbed area. By painting the spot next to your correction very dark and with a crisp, hard edge, your scrubbed area will look bright and fresh.

Now punch in some full-bodied darks into your painting. Don't be timid. Your mid-tones look washed out now, don't they? Now you simply need to add more layers of colors similar to your mid-tones to enrich them.

Make Your Own Darks ▶
The best darks are homemade ones. I like to use a combination of Thalo Green, Thalo Blue and Alizarin Crimson. Used in equal parts they make a deep black, but if on my next stroke I pick up more crimson, the mix will lean toward maroon. More blue on my brush will turn it navy and more green will give me a deep, hunter green. You can have a variety of rich, dark colors from a single puddle of paint. Show this variety in your dark passages.

▲ Looks Can Be Deceiving
This painting looks about finished, but it has few dark values and no blacks.

▼ One Dark Leads to Another
After painting the foreground roof a very dark brown, the rest of the painting felt too light to me. By adding another layer or two of paint to most of the painting, I not only came out with a stronger painting but captured the feel of my all-time favorite painting spot, Our Lady of Victory Basilica near Buffalo, New York.

LET'S SING : 22" x 30" (56cm x 76cm)

Darkening With Washes

While small areas can be touched up easily, mid-sized and large spaces need to be developed with one or more washes. Your first watercolor class was probably devoted to learning how to run a wash. When it dried you probably had a beautiful, pale sunset. I did. Now you need to review the basics and learn how to run a richly colored wash. You need to also consider how to run them in confined and complicated areas. Remember, calling them "washes" doesn't necessarily mean that they are wishy-washy and light.

Tricky washes take a little planning. Large areas, and ones with very complicated edges, need to be broken up into smaller spaces to make them manageable. For instance, if you have a large background around a bouquet of flowers, you could draw in other blossoms or leaves that go off the edge of the page. This would break your background wash into several manageable-sized pieces.

With these larger washes, you should also plan on starting them in the center of your work and running them toward the outer edge. This means that you may be turning your painting around at times and working it upside down or toward the sides. Always clip your paper to a drawing board or piece of cardboard to facilitate turning.

Tip the board up in the back about three inches by placing something under the back of the board. You want your board and paper on a slant so that your wash will run downhill. This is very important. Your extra paint will now bead up at the bottom of the area. Leaving your board flat would make the paint puddle in the middle of the section. Strangely enough, leaving a puddle of paint creates a light spot when dry, never a dark one.

Load your brush with paint for each stroke. Catch the bead of paint from the bottom of the last stroke to move it down the paper. This is essential for a smooth wash. Always pick up the extra paint at the bottom of a wash with a slightly damp brush or the corner of a clean tissue, or it will run back and make a light spot as it dries.

Add a Dark Wash

I broke up the background of the hyacinth painting by drawing flowers so that they now move off of the top of the page. This makes the tricky areas that need a wash smaller and more manageable. Turning the painting upside down and working on a slant, I worked with plenty of paint so the extra paint accumulated in a bead at the bottom of the wash. Pull or push that bead down the page by refilling the brush after every stroke. Pick up the bead at the bottom of the painting with a squeezed out, "thirsty" brush or the corner of a clean tissue. This painting is continued on page 72.

CHECKLIST FOR RUNNING A WASH

1 *Mix a large puddle of strong color on your palette.*

2 *Break large areas into smaller, more manageable ones by drawing in items that go off the page.*

3 *Tip your board.*

4 *Turn your paper upside down or on its side if necessary.*

5 *Apply enough paint that a bead of color appears along the bottom edge of the stroke.*

6 *Before the next stroke, reload your brush with more paint.*

7 *Stroke it across the area, bringing the bead of paint down the paper. Repeat.*

8 *Pick up the last of the bead of paint with a damp brush or the corner of a clean tissue.*

Developing bold shadows is one obvious way to deepen the values in your paintings. But we normally think of shadows as being gray, and even see them as gray much of the time. So we must think creatively about using them to enrich our paintings.

There is no reason to make shadows gray or even routinely blue. You may even take your artistic license and use imaginary colors, or change color every inch or two, and your shadows can still be convincing. Better still, they will add to your painting. As long as you keep all of your shadows running in the same direction, you can even change the angle that they cross your paper if it improves the design of your painting.

Shadows can also be cast from trees, buildings or imaginary objects outside of your picture. They can stabilize your design, as well as providing an area to add deeper values and richer colors.

What Color to Use

Shadows are related in color to their light source. During the day, the sun radiates a pale yellow light. So daytime shadows cast on white snow can be a brilliant, deep blue. That is because blue-violet is opposite yellow on the color wheel. As the sun sets, it casts a peach glow on white objects and shadows become a clear turquoise—again, colors opposite each other on the color wheel. Believe me, I see these colors every evening on my dining room wall. Exaggerate this idea and apply it to a jazz concert with colored lights, and your shadows could be as vibrant and varied as the music.

Be Creative

The lesson to be learned from all of these types of shadows is that you can justify painting your shadows just about any color you feel like. Use them to enrich the rest of your painting. Does the work need warm or cool colors? Does it need something vibrant, or will bright colors overwhelm your message? Put away your reference photo and answer these questions, then enrich your shadows to fit your concept of the painting. Remember, you may want to cut stencils and lift parts of old shadows to introduce more colorful ones.

After you have deepened your shadows, the adjacent colors may look washed out. Now you must go back into these areas and beef them up again. Unfortunately, this is an ongoing, cyclical process. One layer of paint *here* often creates the need for another layer of paint *there*. One day everything will look rich and enthralling, and the next day it will again feel washed out. Don't give up. Go back and add another layer.

▲ Reflected Light

Shadows contain the colors reflected from nearby surfaces. The underside of this soup bowl is in shadow, but I could see that the shadow was tinted slightly with the colors from the quilt. Exaggerating this color bounce made this watercolor sketch much more interesting.

◄ Use Colors Opposite Each Other on the Color Wheel

Daytime shadows on white snow are said to reflect the blue of the sky. This is actually because pale yellow sunlight is opposite blue-violet on the color wheel. Thus, the shadows in this painting are brilliant blues.

ESTES PARK, COLORADO : 22" × 30" (56cm × 76cm)

WAYS OF ENRICHING WITH SHADOWS

Rich, deep colors are essential to a creating the full range of values in a finished painting. Shadows can fulfill that in some areas. Simply painting shadows gray would be boring, so use the opportunity for subtle ways to make them darkly colorful.

There are things to know about color in shadows:

- Shadows most commonly reflect the color of the sky, especially on white and light-colored surfaces.

- They often reflect the color of the object that is casting the shadow. If you hold your hand close to a piece of white paper in strong sunlight, you will see a definite orange tinge to the shadow.

- Shadows deepen and darken the color of the object that they are cast onto. Grass in the shadow of a tree will be a deep green. A shadow cast onto a red wall will be a deep red.

- Translucent or transparent objects add their color to their shadows.

- If your light source has a color, such as in a sunset, shadows are often that color's complement (the color opposite that of the light source on the color wheel).

- Imaginary colored shadows make sense, too.

◄ Add an Imaginary Color
Since this shadow is a large section of the painting, I decided to paint it with a variety of colors. It would be boring if it were a uniform gray.

▲ Add the Color of Transparent Objects to the Shadows They Cast
These shavings are a bit translucent. So in this spot, the strongest light passes through them and warms the shadow beneath them.

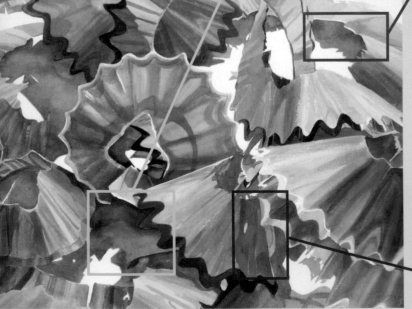

GETTING TO THE POINT : 22" × 30" (56cm × 76cm)

◄ Paint Shadows a Darker Version of the Color They're Cast Onto
Here, the white pencil shaving casts a shadow onto the red pencil shaving. Rather copying the grays from the reference photo, I simply painted this shadow a darker version of the shaving it was cast onto.

Evaluating Your Darks

Now that you have enriched the darks in your painting, you need to evaluate them. There are many ways to check your values. We all have our favorite methods. One of these will make sense to you.

- Squint to check your values.

- Remove your glasses. Like squinting, this may fuzz out the details and let you concentrate on your values.

- Look through smokey-colored Plexiglas or your normal sunglasses.

- Check your painting looking through red acetate or Plexiglas. These turn all colors red and let only the values show through. (Once, my entire class showed up with red, heart-shaped sunglasses.)

- View your painting in the darkest corner of your house. This is my usual method.

- Look at it under photo flood lights. Does the painting look washed out?

- Compare your painting to others.

What, EXACTLY, Are You Evaluating?

- Do you have some darks?
- Are your mid-tones rich?
- Are there enough mid-tones to make the whole painting look rich?
- Are your light areas left in an interesting pattern?
- Are there any misplaced and distracting light areas around the edges? (They have to go.)
- Is this a traditional painting? Then the lightest light is usually next to the darkest dark in the focal area of the work.
- If you are painting in a contemporary color scheme, you have another set of goals. According to this color strategy, all of the colors should be nearly the same value, with little or no white or black. Ideally, with sunglasses on— either red or dark ones—the painting should look all one value, rich and vibrant.

Comparing Values

You need to look for opportunities to compare the values in your paintings to those in other works. Perhaps you have a bold painting of your own. Haul it out every time you are finishing up a piece and compare it to your new work. Buy a watercolor from an artist you admire. Compare every work you do to this piece. Do you have a poster of a strong painting that you love? Compare your paintings to those of Winslow Homer's, and you can't go wrong.

WINSLOW HOMER'S STUDIO : 22" x 30" (56cm x 76cm)

WINSLOW HOMER, American Icon

Winslow Homer (1836–1910), known for his rich, full-bodied watercolors, began his art career as a freelance illustrator in 1857. He came to watercolors late in his artistic life. He was thirty-seven and a mature artist when he began the watercolor journey that would distinguish his career. "You will see, in the future I will live by my watercolors," Homer once remarked. He was right. His watercolors of nature, the sporting life and people had a freshness and immediacy that was hardly attainable in his weightier, slow-drying oils.

Many of his 600 known watercolors were created from this home and studio at Prout's Neck, on the coast of Maine. Other well-known paintings were done on vacations to Bermuda, the Florida Keys and the Adirondacks. Critic Robert Hughes writes that Winslow Homer "did more than any other nineteenth-century American artist to establish watercolor as an important medium in this country."

STEP 4 UNIFY IT

Unity is the most important principle of design. When you see a painting from across the room, what compels you to investigate it? It's the major value and color patterns that grab you and pull you to a painting. Realism, details and variations of all sorts can only be appreciated up close and personal. A painting needs to woo its viewer (or the judge of the show) with its main components before flaunting its details.

Unity within a series of paintings can define an artist's signature style. Whether that artist emphasizes a certain color palette, dynamic uses of white, texture, wet-on-wet painting, or any other technique, the extensive use of these elements of design both unifies paintings and becomes that artist's signature style.

In this book, we're going to take a long, hard look at two ways to unify paintings—design and color strategies. We'll start by unifying our values through design strategies. Many of these strategies appear repeatedly in historic masterpieces. Others are wonderful new ones that keep catching my attention. This chapter will present seventeen of them, some traditional and others that I have loved and used over and over again. I encourage you to collect ones that capture your fancy and draw them on the inside covers of this book. Then cut and paste in photos of paintings that fit the strategies you have found. Using this book as your scrapbook, your ultimate goal will be to find ways of working that resonate with your personal taste.

If you find yourself drawn to one painting, be it a historic master-piece or brand new, look for its design plan. Try a painting using this plan. Perhaps one of your unfinished paintings could be tweaked to fit into the strategy. If you find yourself drawn over and over to paintings with this strategy, you are well on your way to discovering a signature element of your personal style. While the color strategies, discussed later in this chapter, seem to be limited in number, I keep finding new and fresh design strategies. You will, too.

SLOOP DU JOUR : *22" × 30" (56cm × 76cm)*

Exploring Design Strategies

Unify your values. Rather than scattering darks and lights around your painting as they appear in the reference photo, organize them. How? With one of these strategies.

Design strategies are value patterns of lights and darks that have worked successfully and dramatically in art throughout history. Some are also patterns that organize paintings in striking ways, allowing spaces for more content. Both kinds will add punch and depth to your work.

Choose a strategy that is already similar to the value patterns in your painting, then adjust your painting to conform to the chosen strategy as closely as possible. You'll just need to add darker paint in places and to cut stencils and lift paint in other areas. These simple steps will organize your values. The closer you can come to a design strategy, the stronger your painting will be. Here are several design strategies and the paintings that they inspired.

UNDERLYING ABSTRACTION

At times you will read about a painting's "underlying abstraction." This is another way of noting that the painting is held together by unifying value and color strategies. The funny thing about this term is that it implies that the abstraction is applied first, in the underpainting. No. Underlying abstractions can be worked into a painting at any stage. These design and color strategies are your painting's underlying abstractions. I make final choices about halfway through the painting. You can, too.

S- OR Z-ENTRY

This design strategy pulls you into the painting fast! Consequently, it is necessary to contain the painting at the top with solid mid-tones or darks. These keep your eye from shooting off the page.

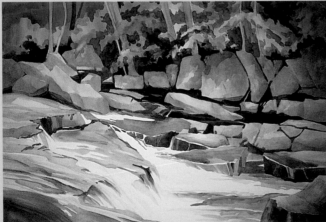

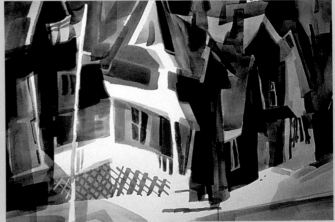

The Z-Entry and Realism
This painting uses an angular, white, Z-shaped entry to lead you into the painting. You will find this very basic design strategy smoothed into an S-curve of a dirt road in many, many country scenes.

Abstracting the Z Entry
Here is another style of painting using an abstract Z-shaped entry. The Z-shape is modified, used here to move you into the painting.

SPRING RUNOFF/NEW SEASON : 22" × 30" (56cm × 76cm) I GREW UP SURROUNDED BY REPUBLICANS : 22" × 30" (56cm × 76cm)

GEOMETRIC DIVISION OF SPACE

Divide your painting into just three or four simple, angular shapes. Any details within the shapes will be minor.

This painting is basically divided into three boxy, angular sections—the rock formation, the L-shape of the water and a sliver of the far bank of the falls.

RIVER ESCARPMENT : 22" × 30" (56cm × 76cm)

FREE-FORM DIVISION OF SPACE

A close relative of geometric division of space, this strategy's main values can be divided into three or four curved pieces. Subdivisions in the spaces, again, retain only minor visibility.

Free-Form Division in Action
Three simple curves define the landscape in this painting.

NOON : Watercolor and colored gesso : 14" × 14" (36cm × 36cm)

VERY HIGH HORIZON

This strategy depends on a very extreme division of space. One band is tiny, and the majority of the painting is very large.

It's important to emphasize that all of these designs can be rotated and still be successful. For instance, this strategy (at right) could also be turned 180 degrees to make a very low horizon with mostly sky. Or it could become a narrow strip on either the left or right.

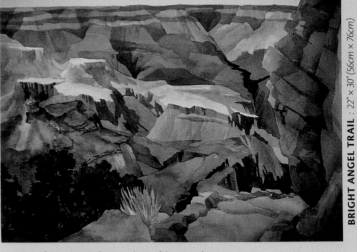

BRIGHT ANGEL TRAIL : 22" x 30" (56cm x 76cm)

Seeing 'Very High Horizon' in Action
This painting was inspired not only by the majesty of the Grand Canyon, but by the surprising flatness of the top of its far wall. I wanted to contrast this flatness with the complexity of the canyon, so I chose the very high horizon strategy.

CONTAINMENT

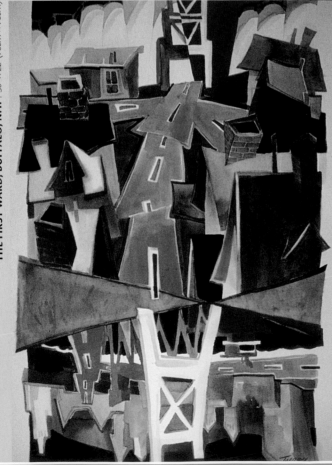

THE FIRST WARD, BUFFALO, N.Y. : 30" x 22" (76cm x 76cm)

A more dynamic interpretation of the very high horizon strategy, not only do containment's slight diagonals suggest movement, the wedge in the middle is under pressure from the top and bottom. This is an edgy design that can add tension to your work.

Seeing Containment in Action
This painting explores city issues. Homes in industrial areas are segregated from downtown Buffalo, N.Y. (shown upside down in this painting) by "brown fields" of industrial waste.

MEDALLION

This design strategy is often used in more abstract paintings. It gives a feeling of importance to your subject, like an award or medal. It is a natural for large, spectacular blossoms.

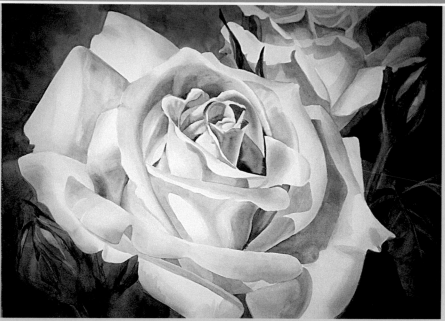

I NEVER PROMISED YOU... : *22" × 30" (56cm × 76cm)*

Seeing 'Medallion' in Action
Some subjects just naturally lend themselves to the medallion, but this strategy can be used to bring importance to all sorts of styles.

RADIAL STRUCTURE

Shapes in this strategy radiate out in the shape of either a fan or a pinwheel.

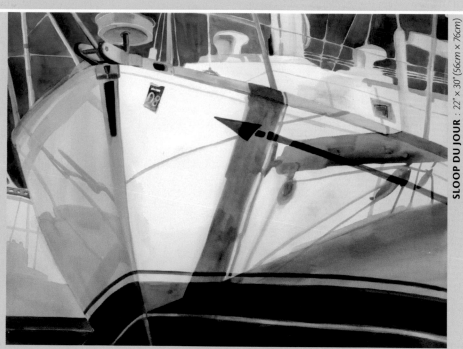

SLOOP DU JOUR : *22" × 30" (56cm × 76cm)*

Seeing 'Radial Structure' in Action
In *Sloop du Jour*, the shadows and the curve of the boat's hull curve out from the bottom of the painting. This is another strategy that is particularly useful for florals. For instance, lily petals fan out from their base.

BOX WITHIN A BOX

Like the medallion, this strategy gives importance to its subject matter. It could feel either comforting or confining.

FINNEGAN'S WAKE : 22" x 30" (56cm x 76cm)

Using Borders

The border in this work creates the box within a box design strategy. It has the look of a TV screen. This structure was developed through cutting stencils and scrubbing the border several times. It's never too late to jump in and try something new to make your painting work.

Repeating Boxes

This began as a realistically painted watercolor within a box of abstracted designs. The repeated boxes within the border unify it while a couple of them turn into envelopes.

MAILBOXES, ETC. : Mixed media on board : 15" x 15" (38cm x 38cm)

THE GRID

I love the grid and use it as often as I can. The grid can be useful in many ways to mean many different things. It resembles a calendar or a comic strip to me and, consequently, I use it to show the passage of time. I call my series done with grids my "Temporal Series." Other artists have used the grid to emphasize variety or abundance.

TURNING THE TABLES : *Mixed Media : 17" × 29"*
(43cm × 76cm) on 22" × 30" (56cm × 76cm) paper

Seeing 'The Grid' in Action

Here I used the grid to show what happens over and over again in life: Things change, and as much as we hope that they are permanent changes, they eventually return to almost the place where they started.

DIRECTIONAL ORIENTATION

Repeating linear elements unifies a painting. This powerful and useful design strategy, like all of these strategies, can be used either vertically or horizontally.

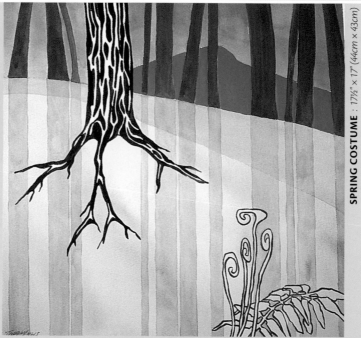

SPRING COSTUME : 17½" × 17" (44cm × 43cm)

Seeing 'Directional Orientation' in Action

This painting is an abstracted version of the traditional fiddlehead fern painting that runs through this book. Although I broke virtually every rule, directional orientation pulled the piece back together.

AXIAL OR CRUCIFORM

This is a relatively difficult design strategy. It can be dynamic when the X marks the focal point, or it can be impressive in religious themes.

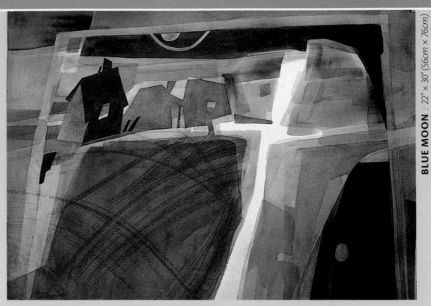

BLUE MOON : 22" x 30" (56cm x 76cm)

Seeing 'The Axial Shape' in Action
This painting was inspired by a walk on Springmaid Beach in South Carolina. The moon was rising at the same time that the sun was setting, so the axial shape evokes the sunshine and moonlight that follow you as you walk along the water.

BRIDGING

When tall objects pass over an area that differs from the rest of the piece, it is called bridging. These tall elements join the top and the bottom together while embracing the center.

SPRING SCENE : 22" x 30" (56cm x 76cm)

Seeing 'Bridging' in Action
Tulips not only bridge the top and bottom of this painting, but bridge my love of painting flowers each spring with my desire to personify houses to vicariously show the people who live in them.

MEANDERING SCAFFOLDING

The artist who took the meandering scaffolding strategy and made it his signature was Jackson Pollack. The strategy is an all-over pattern that fills the page from top to bottom, side to side.

Generally speaking, these paintings exist in a shallow space and may have many small points of interest. It is the interweaving lace and webbing that is the real story in these pieces. Texture may exist for its own sake.

GETTING TO THE POINT : 22" x 30" (56cm x 76cm)

Seeing 'Meandering Scaffolding' in Action
My painting of the pencil shavings, introduced in the last chapter, was created with the meandering scaffolding in mind.

CHECKERBOARD

The checkerboard design strategy is one of the most successful plans presented here. The first two or three times that you do it, though, it's also mind-bendingly difficult.

In using the checkerboard, you need to address your painting's four corners. In the upper left corner, your subject matter will be lighter against a darker background. The lower right-hand corner will be treated the same way. The upper right corner will contain your darker image against a lighter background, as will the lower left corner. (Remember, the checkerboard can be rotated 90 degrees.)

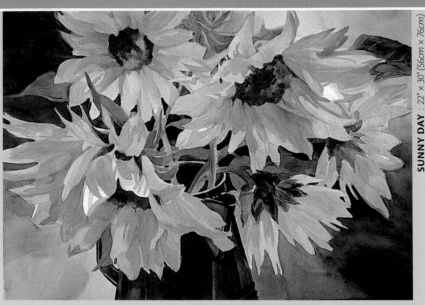

SUNNY DAY : 22" x 30" (56cm x 76cm)

▲ Seeing 'The Checkerboard' in Action
Not only does this painting capture this burst of sunflowers, but it's a distinct example of the checkerboard design strategy. The sunflower in the upper left glows against a dark blue background, while the one in the upper right is a deeper yellow and rests against a pale sky—as does the one in the lower left. The sunflowers in the lower right mimic the one in the upper left by being lighter than their navy background.

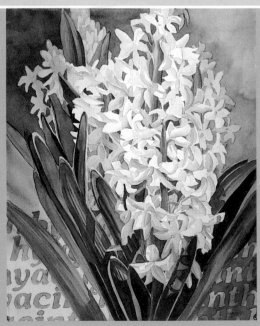

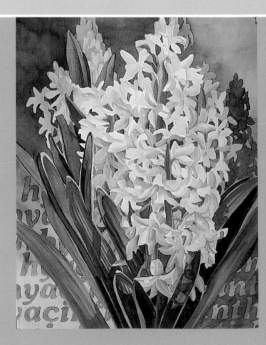

1 Look at the Corners
Here, three of the corners conform to the checkerboard pattern. The problem area is the upper right corner. There I need to create some dark flowers against a lighter background.

2 Create a Checkerboard
By painting in a dark magenta hyacinth stalks (or maybe they're shadows), I've firmly established the checkerboard pattern. This painting is continued on page 88.

This painting is continued on page 88.

CANTILEVERED

This is a sophisticated strategy that can be turned in any direction. The solid section of this could fasten your painting to any of the four edges of the paper. The essence of the strategy is to create both a firm foundation and a protruding structure that floats, falls or hangs in midair.

1 Using the Cantilevered Strategy

I chose the cantilevered design strategy as an underlying abstraction for these fern fronds. Turning the strategy upside down, it both fits the existing painting and gives a feeling of growing out of the forest floor.

But there are problems to solve: My tree is too hard-edged, and the forest floor needs to be emphasized and pulled together with a unifying wash of color.

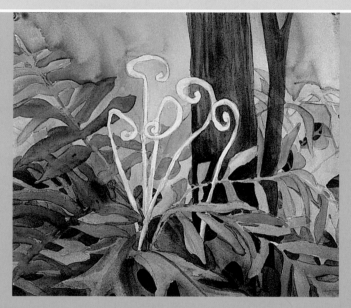

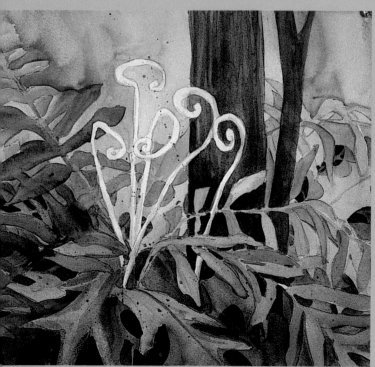

FERN FRONDS : *11" × 12" (28cm × 30cm)*

2 Making the Three Corrections

I glazed the bottom of the painting with Quinacridone Sienna, right over some green ferns. This unifies the area and provides the base for the cantilevered strategy. Softening the left edge of the tree with a damp sponge, I added yellow to the area. This might suggest reflected sunlight, but I chose it simply because it made the painting work. Using a stencil, I made two drawing corrections in the fern leaves. Can you find them? It's surprising, even to me, how much these simple adaptations improve the painting.

PASSAGE AND COUNTERCHANGE

This is the sophisticated cousin of the cantilevered strategy. There is a light area within the dark, anchoring edge, and a dark protrusion into a lighter area on the other side. To make it work for this painting, I need to lay the original design strategy on its side (as shown on the right), and I need to make the dark side much larger.

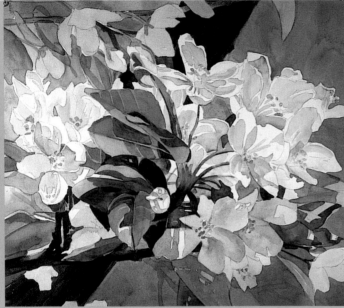

1 Tackling Boredom
This last example of applying a design strategy is trickier than the previous one. Abandoned out of boredom and discouraged by the diagonal limb running off the bottom corner of the page, I figured it was time to kill or cure this painting of apple blossoms.

2 Plan the Changes
I need to lighten or even eliminate the dark diagonal limb; it fights with the strategy. Deepening the sky on the right and darkening the foliage and blossoms on the left will approximate my plan.

Working With YOUR CHOSEN Strategy

Now that you have chosen a strategy that will unify your painting, think of it as an underlying abstraction. Do a sketch or two to make sure you know what you intend to do. Map out your changes. Obviously, you will need to darken some areas. Then, as in Step One, you will have to cut more stencils and lighten other areas.

Sometimes parts of your painting will fight with your chosen design strategy. These need to be softened with a clean, damp sponge if large or a bristle brush if smaller. At times you may have to redesign them or even remove them.

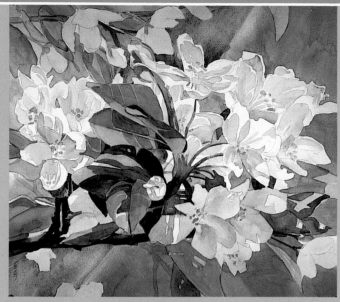

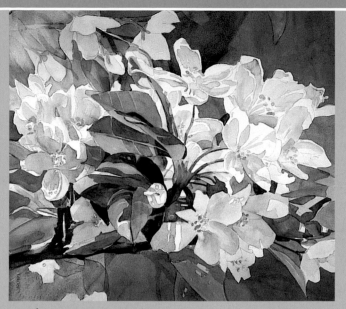

3 **Eliminate the Offensive Limb**
By protecting the blossoms and the twig with a stencil cut from tape, I scrubbed—and scrubbed hard—to lighten the limb that I hated.

4 **Adjust the Values**
The painting begins to conform to the passage and counterchange value strategy after I defined and darkened the blossoms on the left.

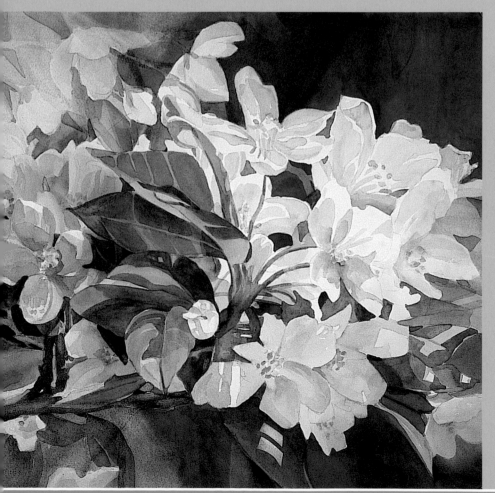

5 **Put It All Together**
Finally, by lightening the leaves in the upper left and tinting the lower left green, you can see the left edge of the paper move from light to darker and back to light. The right two-thirds of the painting does the reverse—dark, light, dark.

Adapting this painting to its value strategy took cutting several stencils and scrubbing and lightening areas to break up space. It also took many brave layers of glazing to finally define the strategy. As I said early in this book, finishing a painting is not rocket science, but it does take patience. You will need to repeat the five steps over and over, at times, to complete a painting. Take chances. Don't settle for a half-finished paint-ing. Kill it or cure it.

Unify It With Color

In this second half of Step Four, we will look at the unity of design through color strategies. These color schemes suggest elegant ways to limit your palette and achieve not only unified color, but also emotional appeal. Each of these has a unique feeling to it—from cheerful to morose and even envious.

You say, but the painting is almost done! It must be too late to change its colors. The answer, of course, is that it is never too late to change anything in a painting to make it better. Kill it or cure it, just don't abandon a painting. Push it toward one of these strategies. Perfect paintings don't exist, but if you can come close to one of these, you will be thrilled with the results.

Why Use a Color Strategy?

Over the centuries, some color strategies have been used over and over to create lasting masterpieces. By controlling your colors, you too can achieve a mature and timeless look in your paintings.

Jumpy, uncontrolled color choices are often distracting. Even if you paint realistically, the colors that you are seeing can be detrimental to a great painting. First, what you think you see may not be what is actually in front of you. You may think that your are seeing, say, a white wall, but it's really tinted by shadows or reflected light. Then, if you are working from photos, the colors in your photo may be off.

Some brands just have stronger colors than others; Fuji film, for instance, tends to have overly intense greens. All the colors in photos taken on an overcast day may be dull and grayed. So, since you will need to adjust your colors anyway, why not organize them in a harmonious way?

How to Use a Color Strategy

As with the design strategies that helped you orchestrate your values, you need to choose a color strategy close to what is already going on in your painting. You will be adjusting your colors in two ways: through washes and through cutting stencils and removing colors that are vastly different from your chosen strategy. So, if you can, choose a strategy that is close to what you have. That way, your changes will be straightforward and easy to implement.

Then you should consider the emotional impact of various color strategies. If the emotional appeal of your chosen strategy is close to what you have already painted, removing and repainting a few stray colors will strengthen the painting's impact. But if, for instance, you want your painting to be more thoughtful, or even sad, you may need to gray down many of your bright colors with washes. This isn't hard to do, but the impact will be dramatic.

AMERICAN CAMOUFLAGE : *22" × 30" (56cm × 76cm)*

Color for Spirited Flavor
Relying on bright, hot colors that, when you squint at them, blend to read 'orange,' gave me the spirited flavor that I wanted in this work. Blue—orange's complement— helped emphasize the brilliance of the hot colors.

CONTENT AND COLOR CHOICES

Painting your personal convictions is hard—we are private people. Exposing our ideas to loved ones, much less others who may not agree with us, takes courage. Remember, you are under no obligation to please anyone but yourself with your painting. If you are comfortable with painting abstraction or semi-abstraction, you can approach difficult ideas ambiguously. Color strategies are one more tool in your arsenal to help you develop difficult ideas.

Both realistic and abstract artists express their content through color strategies. They are a significant tool in our arsenal to help you develop ideas–whether they be difficult ones or pure fun. Think about it, for content is everything.

Color choices are very personal to start with and are a strong way to lean your painting toward your feelings about the subject. Reds and yellows are hot colors. They could be joyous or even angry. The primary colors are playful ones. Gray and black are moody. We all have feelings about what mood a color group can convey. Now we have to lean your painting toward a color choice and a mood. This will give your viewer a gut-level feeling about your topic, not just a visual impression.

Through their controlled colors, the two paintings on these pages imply thoughts, yearnings and moods about my topic. This is called "content." To make watercolors competitive, especially in the larger art world, we have to address content. Watercolor is known for its beauty and the technically talented artists that it attracts, but this reputation for beauty and technique often prevails over creative content. Realistic paintings, as gorgeous as they may be, tend to be quick reads—you understand what they've captured immediately. It is the thought-provoking paintings, on the other hand, that will take the viewer a lifetime to unravel. These have content.

At this step in your work, we're looking at the emotional side of content. In the next chapter, we'll look at adding an idea or two. In future paintings, consider your ideas and emotions at least as important as your technical skills and build them into your work as you go.

Making a Metaphor
In this painting I wanted to show envy between the fastidiously painted, colorful houses and those long in need of a paint job. Of course, these paint jobs are metaphors for the lives of the people who live there. This is unified by the contrast of intensity color strategy that we will be discussing later in the chapter.

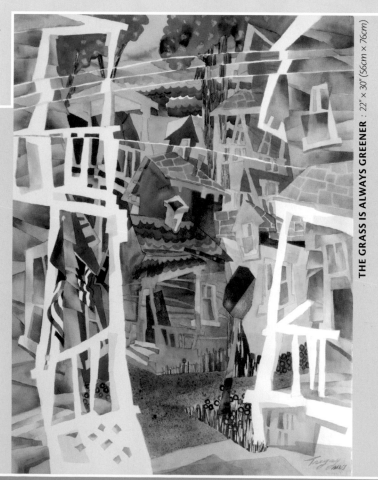

THE GRASS IS ALWAYS GREENER : 22" × 30" (56cm × 76cm)

EXPLORING COLOR STRATEGIES

There are nine very successful ways to get your colors under control for a sophisticated, polished painting.

CONTRAST OF HUE

Red, Yellow Blue

This strategy uses the primary colors—red, yellow and blue—plus black and white. When I first heard about this strategy I thought it was rare and strange, but paintings featuring just these colors are everywhere.

Piet Mondrian chose this strategy for his signature work in the 1940s. The color scheme gave vitality to his famous abstract painting *Broadway Boogie Woogie*. Like Mondrian's work, paintings that use the contrast of hue strategy are fun and light-hearted.

Catch the Spirit

Capturing the fun of the red, yellow and blue color strategy, I squirted watercolor straight out of the tube onto my paper. I then scrubbed the paint around with a bristle oil painting brush. This painting was drawn in charcoal first.

TWO LIPS : *11" × 15" (28cm × 38cm)*

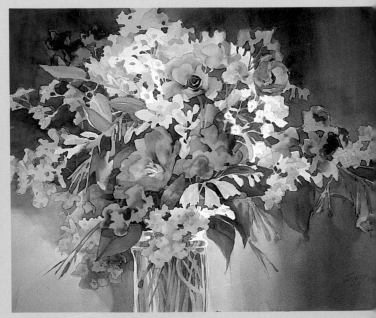

Capture the Spontaneity

This is a bouquet of wild flowers brought to a party in San Diego, California. Being from the Northeast, I was enthralled by the wild flowers that we can only get from a florist. Except for the touches of green, it exemplifies the red, yellow and blue strategy in a realistic painting. The strategy brings out the fun of the beautiful day.

SUMMER IN A JAR : *22" × 30" (56cm × 76cm)*

CONTRAST OF INTENSITY

Bright vs. Gray

Dominance is the key to many color strategies. Contrast of intensity is one of these: it uses a lot of gray with a small amount of bright colors in the focal area. What moods could be expressed with this plan? In *The Grass Is Always Greener* on page 77, it is used to express envy.

Remember, grays can and should be homemade. They can lean toward a color like, say, pinkish gray. This would vibrate nicely against a green-gray area and make both areas come alive. Gray need not be boring—unless boredom is part of your content.

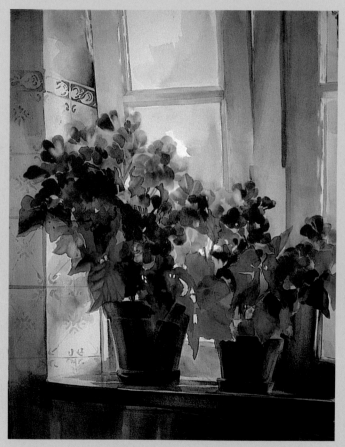

Bright Summer Light

The contrast of intensity color strategy can be used successfully in the full range of painting styles. This is actually from a photo taken in the ladies room at Giverny, Monet's home. The strategy showed the cool, gray interior of the building and suggested the bright summer light outside.

MONET'S SHED : *30" × 22" (76cm × 56cm)*

Contemplation

I used intensity contrast here to make the painting appear contemplative. I wanted a mysterious look that would make the viewer study and grow with the painting.

HOOK, LINE AND SINKER : *Mixed media with collage* : *22" × 19" (56cm × 48cm)*

WARM VERSUS COOL

Contrast of Warm and Cool

Again, dominance is essential to the success of this strategy. A painting using the warm versus. cool strategy needs to have a huge amount of warm or hot colors and a very small amount of cool ones. What mood does this suggest?

Dominated By Cool

This painting was done on a brittle, cold day. The sun was out, but it did little to warm my fingers as I photographed the house. The color strategy warm versus cool was perfect for the weather that day. Here the cool blue dominates and the sun only warms part of the building.

How much warm color can you have in a cool painting (or vice versa)? In a full sheet painting, aim to have an area the size of both of your hands. In a half-sheet painting, make it the size of one hand, and in a quarter-sheet painting, the size of your fist.

THE NEIGHBORS : *Mixed media : 28" × 22" (71cm × 56cm)*

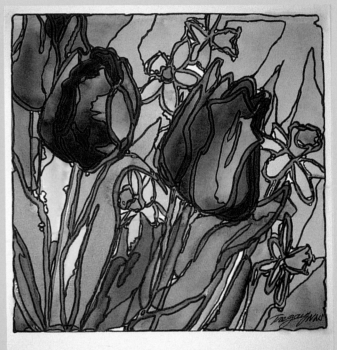

Dominated by Heat

Hot colors dominate this painting, suggesting the first hot day of spring. There is just a bit of cool blue to make the rest of the painting seem even warmer. Use the opposite proportions to express a calm or even sad mood. You can have a very cool painting with a small amount of warm color in the focal area, but one must dominate.

SPRING PALETTE : *Watercolor and ink : 12" × 10" (30cm × 25cm)*

COMPLEMENTARY COLORS

Opposite Colors

Complementary colors are across from each other on the color wheel. Use them next to each other, particularly in your focal area, and they will vibrate and jump. This strategy can be used for a contemporary or modern style or for a very vibrant, traditional look. It suggests an upbeat, positive outlook on life.

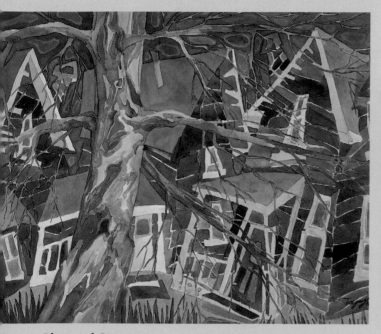

Blue and Orange

Blue limbs against orange houses, then orange limbs against a blue sky. These complementary color contrasts were the inspiration for this painting. What began as an observation of the wonderful colors under the bark of sycamore trees ended up a joyous statement of a street in Buffalo, New York.

AMERICAN CAMOUFLAGE : 22" × 30" (56cm × 76cm)

Red and Green

This is a very direct use of the complementary color strategy. Red versus green can be difficult because these colors turn gray or black wherever they touch. Every time I pass this farm field on the way into Chicago, Illinois, it looks completely different. Here, at sunset, the corn is just beginning to sprout.

VIEW FROM THE BACKSEAT : 15" × 22" (38cm × 56cm)

PANTONE COLORS

Have you ever heard of the Pantone Color Institute? It is a group of people who determine what colors we're all going to drool over in the next few years. Remember in the 1990s when we all decorated in "jewel tones"? Ruby red, emerald green and sapphire blue were all the rage. By 2003 or so, we were suddenly wearing sherbert colors like pink, orange and lime green. In 2007 we decorate,

wear and paint in hues that are (guess what?) tertiary colors. These are, essentially, strong colors with a touch of brown to tone them down. Watch for color forecasts from the Pantone Color Institute; if you need to paint for decorators, or for folks that want a painting that matches their couch, you'll be right on target.

SIMULTANEOUS CONTRAST

Near-Complementary Colors

Simultaneous contrast occurs when a color is applied next to a color that is close to but not quite its complement. These are sometimes called split-complements: examples could be blue and red-orange to yellow-orange, or red and blue-green to yellow-green, or purple and yellow-orange to green-yellow.

POSTCARDS FROM GREECE : 24½" × 10" (62cm × 25cm)

Turquoise and Golden Orange

After a trip to Greece, all of my photos were just too perfect—they looked like postcards. So I taped them together and created this string of "cards." Then I taped them to my wall and painted them. It was great fun to create this three-dimensional look on a flat piece of paper; it's fooled many people. Here I chose a turquoise sky because it was the near-complement of the golden-orange sections of the work.

APPLYING DESIGN STRATEGIES

There are three things you need to consider when choosing a design strategy to unify your painting. First, you need to choose one that is close to the value patterns that you already have working for you.

Second, remember that six or seven of these strategies can be rotated 90 or 180 degrees for even more variety. As you will see, they work well any which way. Finally, consider taking advantage of the deeper meanings that some of these strategies suggest. The cruciform or the box within a box, for instance, give gut level reactions that viewers will feel but may not overtly recognize.

HARMONY OF INTENSITY

All Colors Grayed

In this strategy, all the colors are "grayed," or toned down to the same degree. Add a dab of the color's complement to reduce the intensity of any color. For instance, a touch of green will cut the vibrancy of a hot pink. This strategy can give a sophisticated look, or evoke a gray mood or show a gray day. It isn't easy but has strong potential for content.

WINSLOW HOMER'S VIEW, NORTH : 22" × 30" (56cm × 76cm)

Evocative Grays

These paintings were done from photos taken on the beach in front of Homer's studio in Prout's Neck, Maine. Maine's weather and rocky coast invite gray tones even over its more colorful rocks.

WINSLOW HOMER'S VIEW, SOUTH : 22" × 30" (56cm × 76cm)

THE LAST ONES : *Watercolor and gouache* : 15" × 11" (38cm × 28cm)

The Power of Grays

Tulip shapes get more interesting as they open up and pass their prime. This strategy is a perfect choice for the topic. The blues and even the orange color are grayed just a bit. We watercolorists tend to think of these colors as—yikes!—muddy. We love our colors bright, bold and pure. This strategy fights our normal inclinations, and that is what makes it unusual.

CONTRAST OF VALUE

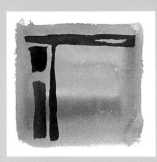

Lights and Darks
This color strategy appears often in traditional paintings, but you will find it in all sorts of other styles as well. Here your focal point is created with the lightest light in the painting next to the darkest dark. It is white against black in many, many cases.

Note that a light color will "sing" when it's placed next to a dark color. This is especially true if the two colors lean toward their complements. For instance, a pale yellow light will glow when its adjacent dark color contains a bit of violet. This is the most traditional color/value strategy—and the most common. If you are looking for something unusual, you might want to avoid this one.

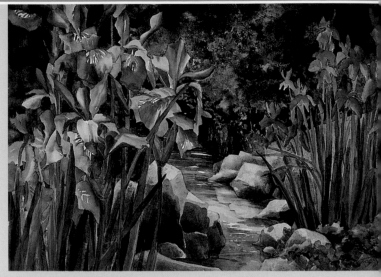

A Traditional Focus
These wonderful little irises grow everywhere in Rockford, Illinois. Here they are in a stream at a fantastic Japanese garden. Such a traditional painting calls for a traditional focal point. The sun-struck rocks and the deep shadows underneath them are a natural focal point—created using contrast of value—that moves you into the painting.

SIBERIAN IRIS : 22" × 30" (56cm × 76cm)

Using Contrast of Value
In Buffalo, New York, there was a huge orphanage, Father Baker's, across the street from a marvelous basilica. The two buildings created an interesting contrast both in architecture and purpose.

The contrast of value color strategy may be a natural for traditional paintings, but it is just as important in contemporary and abstract works. The white path in *If You Don't Behave, I'll Send You to Father Baker's* moves you in and around this painting. You may stop and ponder the dark houses, but your eye moves on easily. Here are a few of the final decisions made for creating this painting.

I cut many, many stencils and scrubbed out many, many buildings in this piece over and over to find the exact placement of each of them. Don't worry about damaging your paper. Your job is to create the best painting possible at whatever cost.

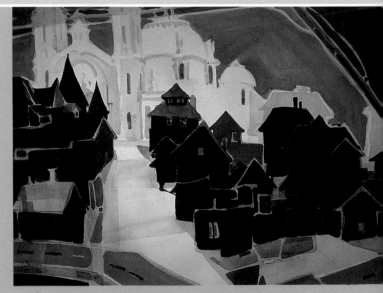

1 Seeing the Problem
Several of the buildings in this painting seemed too rigid. While their dark, ominous colors gave the foreboding feeling that I wanted, their shapes were just too normal.

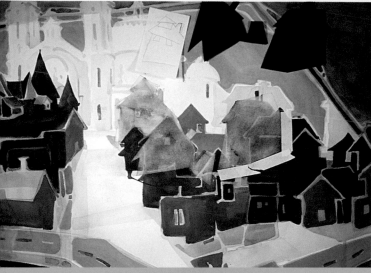

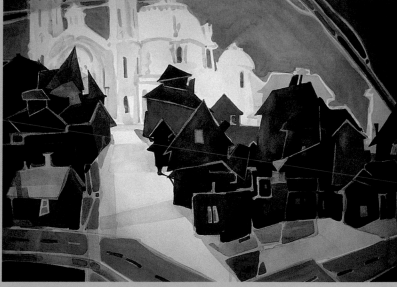

2 Scrub Out Some Color

I laid tape over the area in the middle and cut around the houses that I didn't like. Lifting out the tape, I scrubbed out most of that dark color. The two black shapes that you see up in the corner are cockeyed houses cut out of black paper. I experimented with them and decided to try them out.

3 Repaint the Houses

After many tries, I repainted the houses to my satisfaction. Lightening and tipping the spires on the left made the town begin to rock and roll. Adding some windows began breaking up space. Again, these were cut from stencils and scrubbed out.

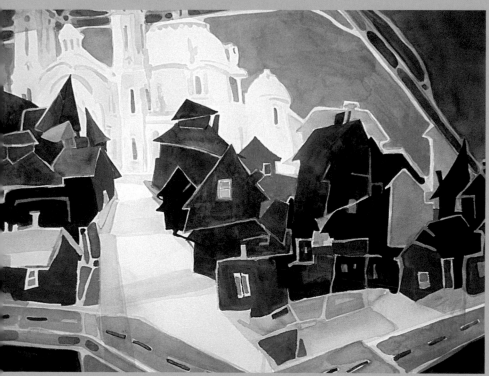

IF YOU DON'T BEHAVE, I'LL SEND YOU TO FATHER BAKER'S : *22" × 30" (56cm × 76cm)*

4 Finish the Painting

Finally, the spires of Father Baker's orphanage were darkened and lengthened to complete my feeling about this awful but very common warning that parents used to give their children in Buffalo, New York: "If you don't behave, I'll send you to Father Baker's."

CONTRAST OF AMOUNTS

A Lot and a Little

As we discussed earlier in this section, dominance is vital in a work of art. You never want to have one half of a painting heavily textured, while the other half is devoted to smooth surfaces. You need to jump in and declare that this painting is about texture and the small, smooth area is there for contrast.

Contrast of amounts can apply to any of the elements of design. In some ways this is identical to the contrast of warm versus cool. From Rembrandt to Clifford Still's black paintings, this strategy is frequently used with all types of work.

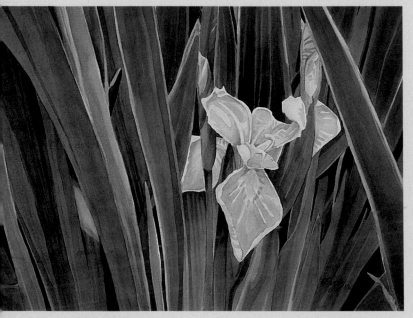

Overwhelming Color

Most of the colors in this painting come from the cold side of my palette. The painting is dominated by every blue that I own and a few cool greens. This cold, wet feeling is exaggerated even more by the contrasting small amount of warm brown at the bottom of the painting—a New Orleans levee.

KATRINA WAVE : *7" × 15" (18cm × 38cm)*

Dominant Green

Greens certainly dominate this painting. Following the contrast of amounts strategy, this extreme dominance makes a unique statement—it's unlike any other floral that I have done.

ONE LAST BLOOM : *30" × 22" (76cm × 56cm)*

CONTEMPORARY COLOR

Fun and Playful Color

In a contemporary color painting, all of the colors are primarily of the same value, thus this strategy is also a "value strategy." Having little or no black or white in them further limits the value range in these paintings. Without the drama of high-contrast values, these paintings exude fun and playfulness.

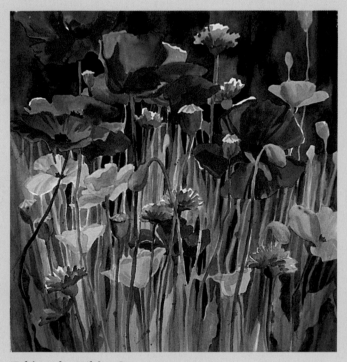

Taking the White Out

If you squint at this painting, most of it becomes all one value. Unlike our last color strategy, there are no whites or blacks in this piece. I nearly cried when I was told that I should try giving up the white of my beautiful paper, but many of my paintings now follow a contemporary color strategy and have no white in them.

POPPY LOVE : *15" × 15" (38cm × 38cm)*

Warmth

The Third Act establishes the feeling of the last warm fall day through its use of warm colors with very little variation in value.

THE THIRD ACT : *Mixed media : 14" × 14" (36cm × 36cm)*

APPLYING YOUR COLOR STRATEGY

Tweak your problem paintings so that they more closely resemble one of these color strategies. You can do this in bits and pieces or with big, bold washes. Whatever changes you decide to make, you can always undo, so be brave and jump in.

Start Small
Before totally reworking a painting or doing anything too drastic to it, try making a small change, such as adding a wash of color, to see how it affects the color strategy.

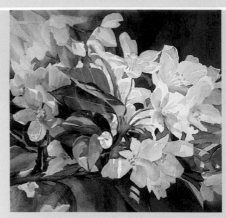

▲ Simple Changes to Move Toward a Color Strategy
Painting a very simple change can reward you with pizzazz. This painting of apple blossoms seemed to contain only cold colors. It needs some kind of contrast.

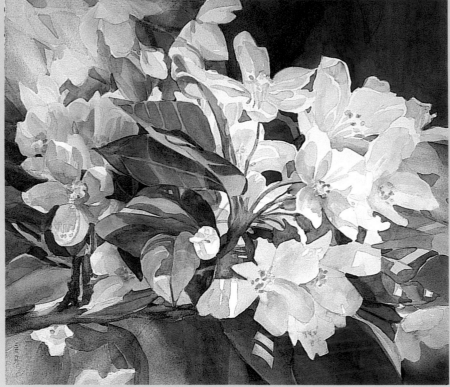

▲ Add Some Warmth
I added three warm, pink buds to the center to warm up the painting a bit. Now it resembles the contrast of warm versus cool. This painting is continued on page 98.

▶ Make Changes With Small Washes
The hyacinth painting was also feeling like all of the colors were cool shades, so I attempted to warm up the painting a bit with a small wash of yellow in the center. Then I added touches of orange. I'm not sure that I like these changes, though. But I don't worry about them right now. Later I can always cut stencils out of tape and scrub out the yellow if I want to. For now I will live with the change. Continued on page 101.

Making Radical Changes

Sometimes, a painting requires some drastic reworking to follow a color strategy and capture the effect you're looking for. You can make radical changes by cutting stencils and using them to lift out a color, then replacing that color with one from your chosen strategy.

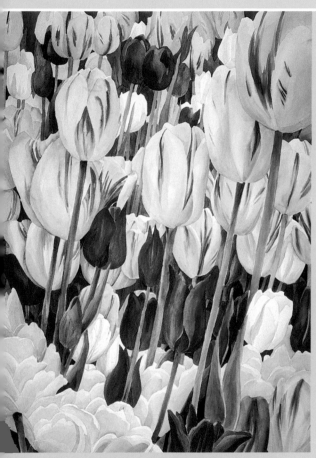

Searching for Vigor
This multicolored painting is of the tulips along Michigan Avenue in Chicago, Illinois. Could it possibly be more dynamic if it leaned toward the contrast of hue (red, yellow and blue) color strategy?

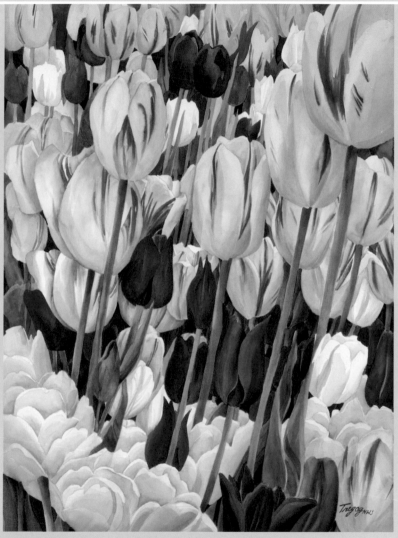

Pushing Toward Contrast of Hue
I was game to try out this theory. I began removing green stems and replacing them with blue ones, but, eventually, I found that I needed to keep a bit of green, especially where the green involved the red tulips (the red/green complements made for interest).

MICHIGAN AVENUE GOLD : *30" × 22" (76cm × 56cm)*

ORGANIZE COLOR WITH LARGE WASHES

Making big, bold changes at the last minute is fun and fascinating. You can run washes of areas to lean the colors toward those in your chosen strategy. For instance, a red or brown wash will warm up an area, while a turquoise will cool a painting down. A wash of a color's complement, of course, grays it to conform to the contrast of intensity strategy.

There are many different solutions to problem paintings; just don't be afraid to jump in. Yes, you might spoil the painting and have to go back to Step One to cure it, but we all know that unfinished paintings can languish for years in the back of the closet. Now is the time to revisit them.

1 Spotty, Inconsistent Color
I painted this on location at a garden shop. I loved the bright colors peeking through the hanging baskets of white geraniums. Unfortunately, those were the very geraniums that were on sale that day—people kept buying my subject matter! So the painting was pretty jumpy when I got it home.

2 Applying Big, Scary Washes
I decided to dive into the painting with a huge wash of Alizarin Crimson. This neutralized some of the greens and toned down the geraniums that were jumping off the rack. Everything came out way too pink, though.

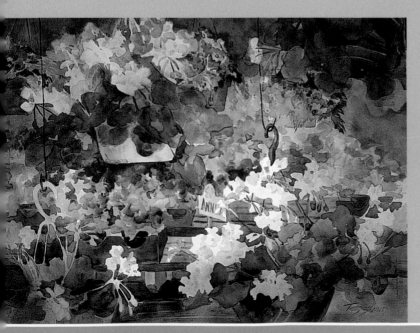

3 Tone It Down Again
By experimenting with washes of Quinacridone Sienna (which turned out to be way too bright), then Burnt Sienna, the painting began to pull together. Some of the violet and red flowers now seemed washed out and needed another coat of paint. It's left with a few clear greens and some pure white in the center, or focal area, of the painting.

What color strategy is this painting closest to? It is close to both the complementary colors strategy, in which red and green dominate, and harmony of intensity, in which many of the colors are, in this case, browned to the same degree. The important thing is that by laying in the big washes, the colors in the painting are now under control. This painting, *The Garden Shop*, is further developed on page 108.

A Unified Painting ... With a Surprise

This painting went through many metamorphoses to arrive at the finish line. It began its life as a hot painting with a cool, blue roof in the center. First the map had a light orange background, then, leaving some of the orange showing, I painted most of the background the bright red that you see here, but that color strategy just didn't seem to be working. Finally, I designed one more border. After covering the map with tape and cutting around it, I scrubbed back some of the bright red and painted it navy. Now the painting is close to the contrast of hue (red, yellow and blue) color strategy.

The Next Step

Look carefully and you will see a hidden message in *Land of Opportunity*. Before I started this piece, I adhered plastic, stick-on letters to the map. They read "Where any boy can grow up to be President." This painting is now hanging in a hotel in Buffalo, New York, where, I was told, the governor of the state spent a long time studying it. The message also intrigued the art critic for the Los Angeles *Times* enough to mention it in a review.

This is my "surprise" for the work. It surprised a governor and an art critic. The next step toward finishing your painting is creating surprises in your paintings. Surprises add content.

LAND OF OPPORTUNITY : *22" × 30" (76cm × 56cm)*

STEP 5 SURPRISE US

Now I'm going to ask you to take the issue of content one step further. The gut level feelings that you have created through your color and value strategies are terrific. In many paintings, developing the mood of the piece is just what you need. But you don't need to stop there. As we have in the other aspects of finishing your painting, let's push the content. The purpose of art is to make the viewer think, so let's give them something to think about. Let's surprise them.

Content takes an ordinary painting and makes it engaging. If you find just the right solution, it will make your work exciting. And at times you will come upon a truly thought-provoking answer to the question "Where is the surprise?"

The first problem that we need to address in Step Five, "Surprise Us," is where to get your ideas. Ideas are tough to pin down. Some are fleeting and some are very personal. How do we get them out?

FENCED : 22" × 30" (56cm × 76cm)

WHAT'S THE SURPRISE?

Deciding what type of surprise (Content? Technique? Color?) is the first part of this step.

Brainstorming

Start a list in your sketchbook of possible ideas for polishing off your current painting. Write down your silly ideas as well as your gems. Both will generate new, more complex thoughts.

Some of your initial ideas might be trite or corny. For floral paintings, perhaps butterflies and ladybugs come to mind. As "cute" as these may be, I need to write them down in order to explore them better or to mentally set them aside. *Perhaps these could be developed into an overall pattern. Can I abstract them? What about seed packets? Garden tools? Sunglasses?*

This is brainstorming. It's an invaluable tool for artists. Generate—and list—ten ideas, both serious and funny, and then pick the best one.

Painterly Surprises

If you are working on a serious painting and aren't ready to express your inner thoughts on paper for the world to see, you could explore simple ideas that will personalize your technique while adding some punch to your design. A technique could be as simple as painting all of your flickering light spots in your painting hot orange or a cool turquoise. Making these spots really flicker and jump adds life to your painting.

Or you could, judiciously, add a different medium to create an eye-grabbing section, such as a flat, opaque area. For true opaques I use acrylic gesso tinted with watercolor straight from the tube. Gesso is extremely opaque. Gouache is more transparent then gesso, so I save that for when I want a subtle opacity.

Collage, lacy pen and ink lines and many other media and techniques are at your disposal too. Consider using them, but be sure to integrate your new medium into the painting carefully and fully— you want it to be eye-catching, not out of place.

FUCHSIA : Watercolor and gesso on textured clayboard : 12" × 12" (30cm × 30cm)

Creating Contrast With a New Medium

Fuchsia are such a transparent, delicate flower that I decided to emphasize this by contrasting the blossoms with some square, solid, opaque boxes. These are painted with watercolor mixed with white and acrylic gesso, and outlined in pencil.

Drawing Materials

Add a different flavor to your painting with a drawing material. Charcoal and watercolor crayons can make a painting gritty and subdued, or a gold gel pen can make a painting glitter!

Drawing Materials and the Lines They Make

1 Caran d'Arche watercolor
2 Crayons
3 Charcoal
4 Pigma pen
5 Papermate Correction Pen
6 Gold gel pen
7 Pencil

1 Watercolor crayons
2 Watercolor crayons scrubbed with a damp brush
3 Watercolor crayon heated on heated paper
4 Charcoal
5 Charcoal smeared with my finger
6 Charcoal scrubbed with a dry bristle brush
7 Pigma Micron pen, black 08 width
8 Papermate Correction Pen
9 Gold pen
10 Pencil

Combining Media

In this painting, I used watercolor crayons to show the setting sun as its light was bouncing off the ice-covered trees. I chose to stylize the painting by drawing circles. They vary in color and size and are peppered throughout the painting. The small, light-colored trees are painted in white gouache tinted with watercolor to integrate and truly "mix" the media.

NOVEMBER LIGHT : *Mixed media* : *20½" × 20" (52cm × 51cm)*

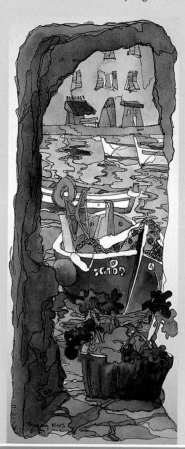

Starting With an Ink Drawing

Begun in pencil, I finished this drawing in ink and then painted it. Finally, I traced around all the irregularities in the sketch to create a lacework of ink lines that holds the piece together, and then adjusted the values once again when I was inside, out of the bright Italian sun.

CAMOLI, ITALY : *Watercolor and ink : 6" × 14" (15cm × 36cm)*

TROMPE L'OEIL TO FOOL THE EYE

Perhaps you could add some very realistic trompe l'oeil item to your painting to fool your viewer's eye? Such items could be fake pushpins "holding up" your painting, or a very realistic pencil "lying" on it. What other art tools could you paint in instead? What would you be saying about being an artist by adding these things?

How do you put in realistic items at this late stage? First, you need to set the item up with a strong light, because the shadow is very important in fooling the eye. Then draw the item and its shadow on scrap paper. Make sure that you have it the right size for your painting. Transfer the drawing onto your painting by taping your drawing to the window, taping your painting over it in the right position and tracing it, or by tracing with carbon transfer paper.

Now cover your tracing with packing tape or a transparent, matte masking film and cut a stencil for the item out of the tape. Don't cut out the shadow. Scrub, blot and dry the area to be repainted. Now remove the tape and paint in the shape. Paint in the shadow over the original painting. That way, it will move over the items already in the work.

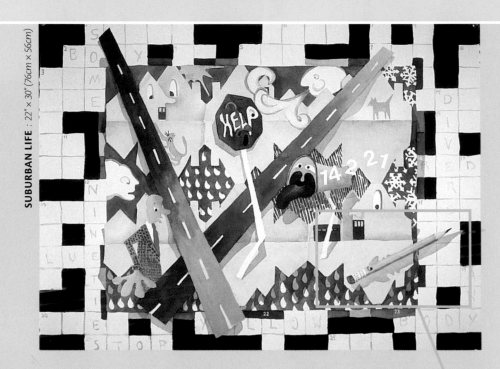

SUBURBAN LIFE : 22" x 30" (76cm x 56cm)

Fooling the Viewer
This pencil, even though it has a face on it, fooled me several times. I kept trying to pick it up while I was framing the piece, and I'm the one who painted it!

Playing With Shadows
Realistic items and shadows are great for fooling the eye.

Adding Interest and Whimsy
The border of this fun painting was too plain, so I decided to expand the humor out to the edges of the work. I drew the pushpins, cut the stencils, scrubbed them out and painted them yellow. They finished off the painting's border and added a touch of realism to the whimsical piece.

LAND OF OPPORTUNITY : 30" × 22" (76cm × 56cm)

GATHERING IDEAS for CONTENT and FUTURE SURPRISES

Whenever I look at a work of art, I think of museum hopping with Marilyn Hughey Phyllis. After long days of teaching, we would go to a museum. There she would spend five minutes looking at a painting before moving on to the next one. Finally I asked her what she was staring at in these works, and she said she looked for three things. First, what problem did the artist set up for himself? Second, how did the artist solve that problem? And, third, how can I use that solution in my own work?

Study all kinds of art. Art that's very different from your own can lead to inventive solutions. Art and crafts from other parts of the world will give your watercolors a unique edge and a signature look. Glue samples of artistic possibilities into your sketchbook where you will run across them every time you paint. (Glue sticks are wonderful.) Maybe one of them will become your next "surprise."

ADDING CONCEPTUAL SURPRISES

What more can you say about your topic? Brainstorm again. You might decide to make your floral painting shout RED! Or you could add more items and make it a statement about abundance. How about adding my ideas of seed packets, butterflies or gardening tools to a floral? Keep generating ideas and you are sure to come up with a very satisfying one.

Adding the New Ideas

Here's our apple blossom painting once again. It's a "nice" piece, but why stop at "nice"? What can we add to give some extra meaning to the painting?

How can you possibly make drastic changes on such a dark background? Let's review cutting stencils and scrubbing out paint for drastic (and subtle) changes.

1 Draw the Apples

When making complex changes, draw them out first on scrap paper to make sure they're the right size and effect before adding them to the painting. It may take a few tries to get the size of the apples and their spacing right. Since the area is dark blue, I used carbon transfer paper to transfer the drawing onto the painting. Scribbling on the back of your drawing and transferring it that way is another possibility. Cover the area with stencil material.

Brainstorming "SURPRISE" Ideas

Let's brainstorm about this apple blossom painting. What could be added to this painting to make it more interesting?

- *Butterflies*
- *Birds*
- *A hummingbird*
- *Buds opening in stages*

Or, in this case, an apple being eaten!

- *One bite gone*
- *Several bites gone*
- *Mostly gone*
- *Apple core*

Run the four of them down the right side of the paper.

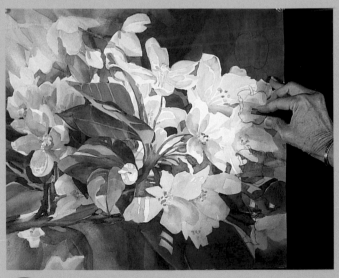

2 Cut a Stencil

Cut around the drawing using a single-edged razor blade. You will feel—and hear—the texture of the paper as you cut. Use the corner of the blade to pick up the tape where you intend to scrub out paint.

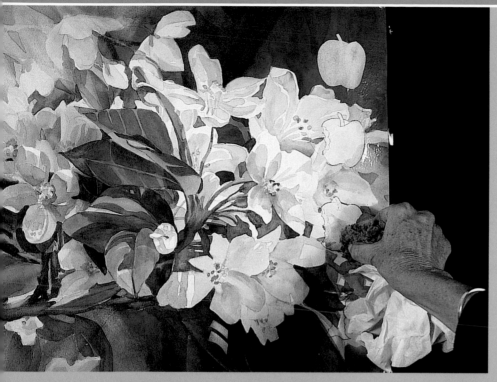

3 Scrub Out the Paint

With a slightly damp, soft natural sponge and clean water, scrub out the paint. Even that navy blue picks up easily. Rinse out the sponge three or four times while doing this, then blot up as much moisture as possible with paper towels. Remove the tape or masking material and blot again, then dry the area with a hair dryer.

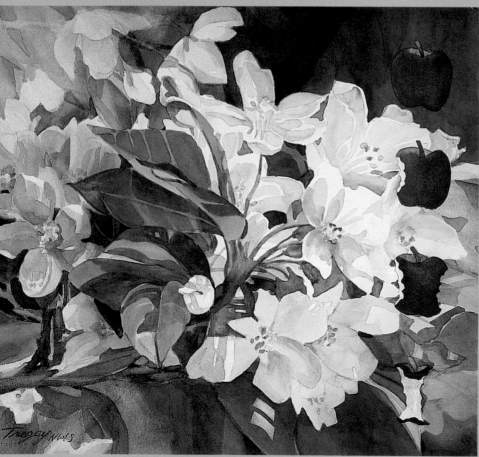

4 Add the Changes

Finally, paint your changes. *Presto!* Content. To see the final step in this painting, turn to page 110.

WHEN POTENTIALLY WONDERFUL PAINTINGS ARE BORING, SURPRISE US

Here is a favorite painting of mine. It began as a perfectly good painting of derelict boats sitting in a field in Oregon, but it was so ordinary. When I took the reference photos, I carefully put the lens of my camera through the holes in a chain link fence. I didn't want the fence to get in the way of what I thought was a perfect shot.

1 Strong But Boring
This is a perfectly good painting, but oh so average. Where is my surprise? There is none.

2 Finding the Right Content
What this painting lacked was content. The fence I had so carefully eliminated from my reference photo was just the element I needed to show the despair of abandonment. So I took a photo of a chain link fence near my house and drew it onto my painting. The painting is on Arches paper, so I was able to cover the whole painting with packing tape. I cut out the fence along the lines of my drawing and scrubbed it. Hard.

FENCED : 22" × 30" (56cm × 76cm)

3 Sending the Message
Freshly painted shadows rounded out the wires of the fence and made them overlap and intertwine. What does this painting say about the boats now?

NAME THAT BABY!

As we close in on finishing our paintings, we can use one more tool to polish the pieces, add more content and even make them more saleable. Great paintings deserve great names.

Start a list of possible painting titles. Look at book titles, jot down intriguing phrases and song (particularly jazz) titles. I saw the title for *Master Disaster* many years ago in an ad in a technical magazine. Great titles are everywhere. I now have a list of more than 600 possibilities on my laptop, and I continue to brainstorm new titles. You can, too. Write your list of possible titles—good ones and silly ones—in your sketchbook where you can easily go back to them.

Brainstorming a Name for the Hyacinth Painting

I have pulled all sorts of possible titles from my computer list for this work and copied them in my sketchbook:

Visual Language	*Spring Awakening*
Watercolorful	*It Seemed Like a Good Idea at the Time*
One Thing I Know for Sure	
But is it Art?	*The Spelling Lesson*
Highly Hyacinth	*Things We Didn't Know*

Does *Highly Hyacinth* generate any alliterative ideas for you? Do you like funny titles, or are you more serious? I've already admitted I'm a lousy speller... I think that I'll call it *The Spelling Lesson*. Adding humor, truthfulness and a personal statement to a floral painting makes it unique.

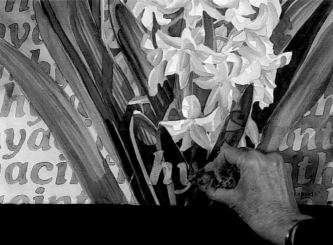

1 Adding the "Lesson"

What can be the surprise in the hyacinth painting? I'm a terrible speller, and the word "hyacinth" has plagued me throughout this book. Why not write it right across the bottom of the painting?

After cutting a stencil of the letters, I gently scrubbed them so the lettering turned out subdued, not stark white, then added green.

2 Clue In the Viewer

Give some serious thought to your painting titles. Although judges for big shows don't have time to read and ponder the titles of a painting, the public can really relate to the content—and to you—if you give them this verbal clue.

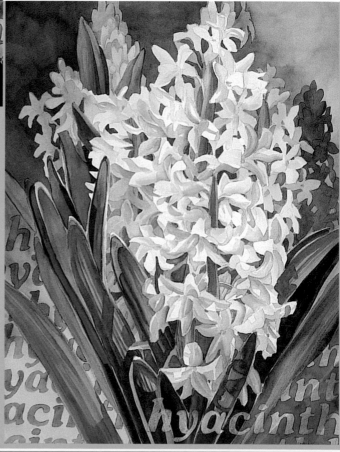

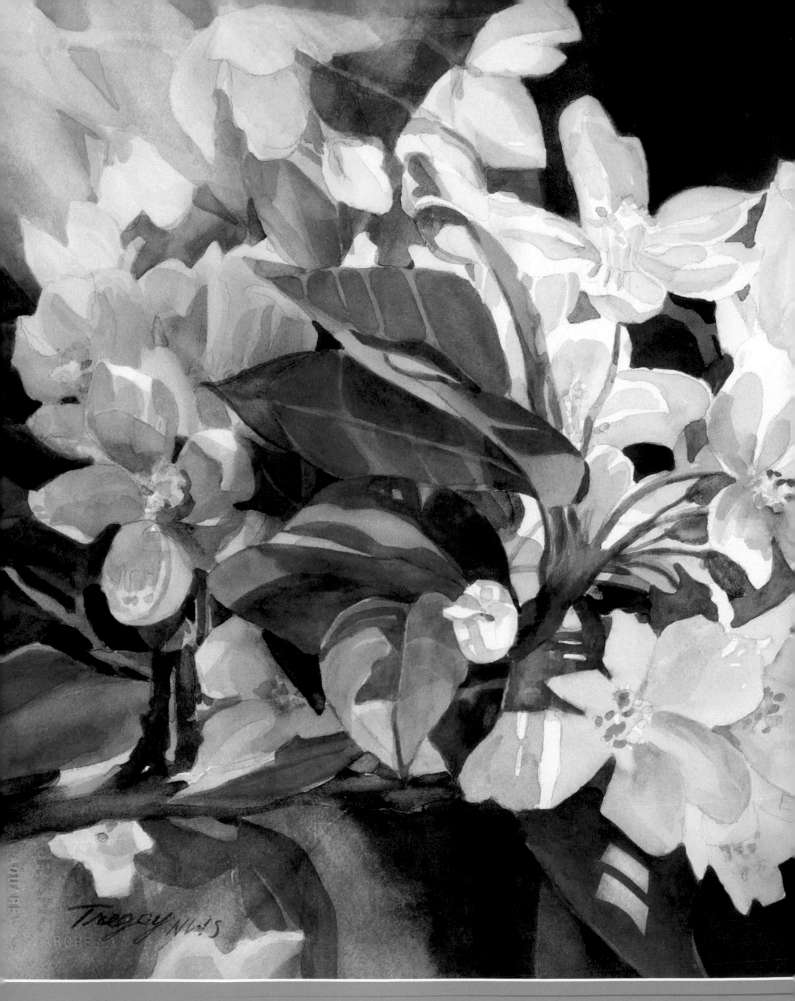

THE CORE OF IT : *15" × 16" (38cm × 41cm)*

EVALUATE IT

You've made it to the home stretch: The end is in sight. Congratulations!

Now, however, you need to ask yourself some hard questions. It is difficult to have other people critique your paintings. They may try to be too nice because they don't want to hurt your feelings or discourage you, or they may not understand what you are trying to do or say and will lead you astray from the goal of your painting. You need to learn how to become your own critic. You know how rough and demanding you can be on yourself. Now your purpose as a painter is to encourage yourself and to see growth in your work.

As you look at your painting, what questions do you need to ask yourself? Primarily, you should ask, "Is this the best I can do?" Unfortunately, the answer to that is always no. But after you work your way through this book, this response shouldn't paralyze you. As you now know, this question—and the answer—become more manageable and less frightening if you break them down into small pieces.

CHECKING EVERY SQUARE INCH

Using your hands as your viewfinder, map out your painting. Start at the top left and look through your hands. Ask yourself, "Is this square the best that I can make it?" Then move over a few inches and ask yourself again, "Is this as good as it gets?" Cover each and every section of your painting.

What Are You Looking For?
Mainly, you are looking for four things:

1. **Ugly areas.** In mastering your disaster, have you created any new ugly areas? Any dead colors? Any misguided painting? Any rough edges or brushstrokes that you want smooth? If so, you will need to go back to Step One, Lighten Up. Draw in your change, cut a stencil and lighten or remove the area. Repaint it freshly, correctly and smoothly.

2. **Boring areas.** Move your viewfinder across your painting to determine if there's enough going on in each section to keep your interest. You may need to go back to Step Two, Break It Up. Adding a few leaves or blossoms or putting in an abstract paint stroke or two might do the trick. Remember, don't break up space by putting in something that you can't paint well, such as a window.

3. **Wimpy areas.** As you move your hands across the painting, look to see if every section is dark enough. Is the color rich? Do you need to go back to Step Three, Enrich It, and beef up some areas? Basically, you may need to add two or three layers of the same initial colors. Second verse, same as the first, I tell myself.

4. **Disjointed light areas.** Are there any flickering light or white spots around the edges? Are they distracting? Do they pull your eye away from the focal point? They probably do, so paint them in. You might be able to wash a single color over the area to unify it, as in Step Four.

Check Your Focal Point
Now you need to check the focal point, path or area of your painting. As the names imply, the focal point is a small spot that attracts the eye, a focal path is a path that leads you into that spot or around the painting, and a focal area is a larger space that is central to your painting. You may choose to use more than one of these in a painting. Basically, you want to move the eye around the painting and end up near the center. And you don't want the eye to inadvertently shoot off the paper—and on to the painting hanging next to it in the exhibition!

The best way to do this is to first look at your painting in a dark corner of your studio. Details are hard to see, but changes in value are obvious. Are your light areas near the center of the painting? In a traditional painting, do you have your lightest light next to your darkest dark? This is not necessary, but it sure helps.

Are Your Colors Rich?
Is your painting dark enough to stand up against other strong paintings in an exhibition? Is it dark enough to photograph well? Look at your painting in strong light. Do parts of your painting or the whole thing look pale and washed out under bright light? If so, enrich it. Add additional layers of the initial colors.

View It In the Dark
The painting *Icons and Relics* (next page) has lots of high-contrast movement which allows the viewer to move freely between its two sections. When viewed in

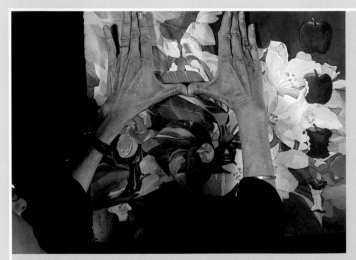

Your Viewfinder
Use your fingers as a readily available, portable viewfinder. Just touch your thumbs together and make a square.

the dark, does this path lead you around the painting, but not shoot your eye off a corner?

View It In a Mirror

Look at your painting in a mirror. It will look completely different to you. You are now an unbiased stranger checking out your own work. Quick, ask yourself where your eye goes first. Is this where you want it to go?

Catch a Glimpse of It

Now stand your painting up where you can catch a glimpse of it as you go about your daily activities. Again, ask yourself where your eye goes. Does it

move around, and then settle near the center of the work? At this stage you will find yourself constantly tweaking the painting. I say go for it: Changes generally only make a painting better.

Ask a Family Member

Now you will have to ask a family member to help you critique. Grab a family member and say "Quick, where did you look first?" Don't let them dawdle over the piece and then answer you. You need a quick first impression. You've spent a long time with this painting, and now you really need an outside opinion.

◄ Look At It In Reverse
Check out your painting in a mirror to get a fresh look at it. How do the patterns of contrast hold up now?

▲ Turn Off the Lights
Looking at a painting in the dark reveals how the value changes lead a viewer's eye through a painting.

► Checking Every Square Inch
This painting is a study of some icons from four periods of Italian culture. Because the story of this painting is the movement between these periods, I wanted the eye to flow about the piece. Using my fingers as a viewfinder, I asked myself these questions: Do I love every square inch of this painting? Are there any boring areas? Do any areas need more paint? Are the light areas organized to lead me into the center of the painting? Do I have a strong focal path?

ICONS AND RELICS : 17" × 24" (43cm × 61cm)

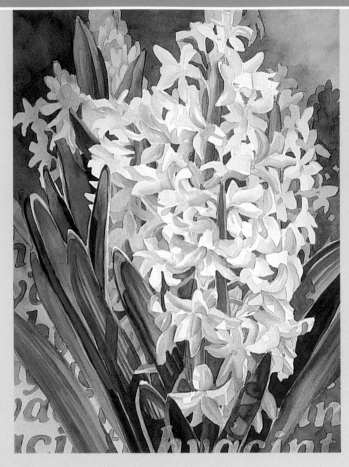

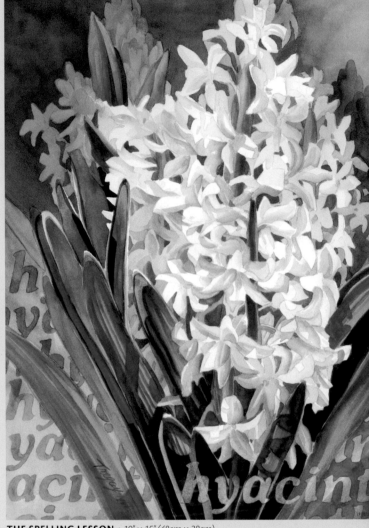

THE SPELLING LESSON : *19" × 15" (48cm × 38cm)*

Fine Tuning *The Spelling Lesson*

Our hyacinth painting needed to be tweaked in many ways:

1 The contrast in all three mauve corners was too strong. My eye was drawn to the corners rather than to the central flowers. So the corner blossoms and the lettering in the lower left needed to be toned down with a wash of MaimeriBlu Reddish Violet.

2 More buds needed to be added to make the dark shape on the right side more interesting.

3 I was unhappy with the ugly gold color in the center. So I cut stencils and removed it in eight or ten of the petals. Some were left white, some were painted a pale, clean yellow and a few dashes of pink were added for variety.

4 By darkening the stem, I added contrast in the painting's center. This helps direct the viewer's eye into the work.

5 I signed the painting on the leaf because I didn't want the signature to interfere with the word pattern.

WORKING ON YOUR FOCAL POINT

As you observe your painting, you may begin to see areas that pull your eye away from the focal point. These might be areas of strong light and dark contrast outside of the focal point, or they might consist of a bright or very different color that diverts your eye from the focus of the painting. Sometimes the problem lies in complementary colors, those opposite each other on the color wheel, that vibrate against each other and distract you. Finally, you may have some sharp, pointy shapes in your painting that lead off the page. These are all ways of creating focus, but when misplaced, they distract your viewer and need to be toned down, lightened or softened.

At times a sharp, clean edge in the center of your focal area will create the final bit of interest for your viewer. After you've added several layers of paint to your piece, the nice sharp edges that you started with may have become blurred, rough or overlapped. You may decide to clean up a few of these edges, especially in the focal area. Cut another stencil, and scrub out and clean up these edges. Now dry the area completely and paint in a dark, rich color beside your new, light edge. It will look clean and fresh and will enhance your focal area.

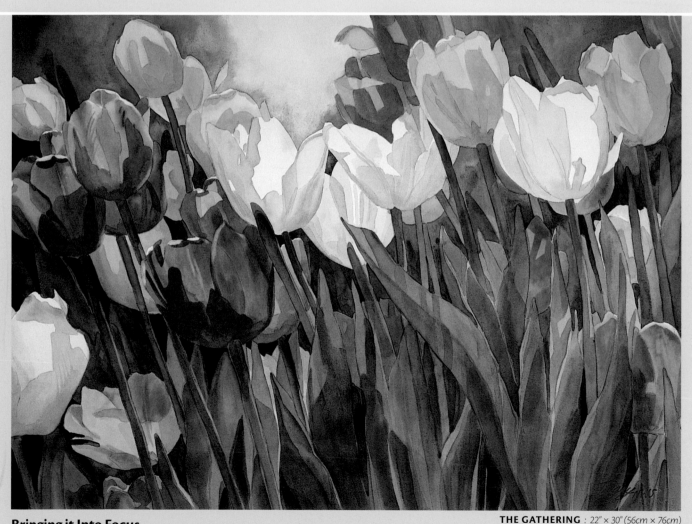

THE GATHERING : 22" × 30" (56cm × 76cm)

Bringing it Into Focus
The sharp, clean, dark edges and leaves around the white tulips make a strong focal point before your eye moves into the brilliant reds.

Creating a Focal Path

Remember when I put dark washes around the edge of *The Garden Shop* in Step Four? These washes did unify the painting, but, as sometimes happens, they also created a new problem: By changing the unifying strategies in the piece, the remaining white geraniums became my focal area. They are now the lightest elements in what is now a dark painting.

But these white flowers are really too low in the piece to make a good, functional focal area. It's not only too large, but it is also very scattered. It simply can't be made into a single focal point. So my only other choice is to make the white blossoms into a focal path that is meant to lead your eye around and then into the middle of the painting. Watch this focal path develop.

Because the remaining white geraniums were too low in the painting, I began creating a path of light shapes instead. To develop this path I took advantage of the grouping of blossoms at the bottom, curving up toward the center. By drawing a few new blossoms in the center area with the red geraniums, I felt that I could move the viewer's eye into the middle of the painting.

Going back to Step One, Lighten Up, I covered these drawings with tape, cut a stencil and scrubbed the blossoms almost white. Now the viewer's eye moves into the painting with ease. There is no need to make the blossoms pure white—they could be in shadow or picking up reflected light from other leaves and blossoms.

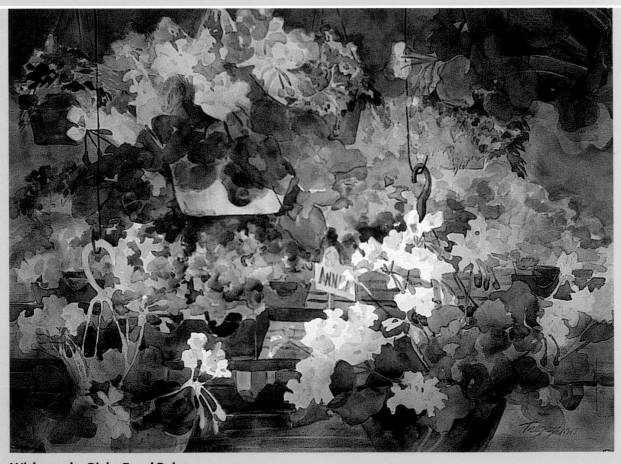

Without the Right Focal Point
The Garden Shop as we last saw it on page 90, where we adjusted its color.

Six new blossoms and buds begin to create a focal path.

More light blossoms were added to create a nice curve to the focal path.

One light blossom and a bud at the upper left of the path serves to stop the eye movement.

The red wash unified the painting in Step Four (page 90), but it made some of the green leaves turn an ugly brown. Several were lightened by using a stencil and were perked up with M. Graham's Sap Green, which is fairly opaque, and Winsor & Newton's New Gamboge. Opaque colors can be safely used in the last layers of your painting.

THE GARDEN SHOP : *30″ × 22″ (76cm × 56cm)*

WARMING UP A COLD PAINTING

Now ask yourself if you have made your painting too cold. Our darkest colors are very cold ones—Thalo Blue, Thalo Green and Dioxazine Purple, for example. Even reds can have a cold feeling. Alizarin Crimson and many of the colors with Rose in their names are cool, and in excess, these colors can look chilly.

In being enriched over and over, your painting may have become colder than you intended. Do you need to balance your warm colors and your cold ones again? A warm yellow, such as New Gamboge, will turn cold blues and greens into a warmer green. The apple blossom painting, *The Core of It,* had definitely turned cold in the process of correcting its problems and organizing its design. New Gamboge both warmed up many of the greens and added more sunshine to the piece.

Cold blues can be warmed up with a cool pink or red, such as Winsor & Newton Permanent Rose, a Quinacridone pink. Beware of using warm reds such as Cadmium Red. These can turn blues brownish.

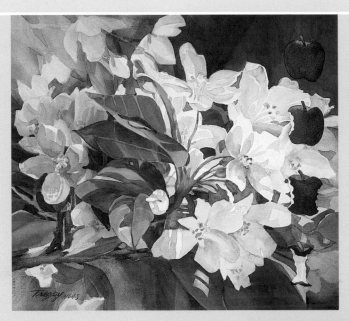

When to Add Warmth
Our apple blossom painting has become very cold, while the center apples don't fit because they are too warm and orangey-red. Subtle temperature changes need to be made to balance the warmth in this piece.

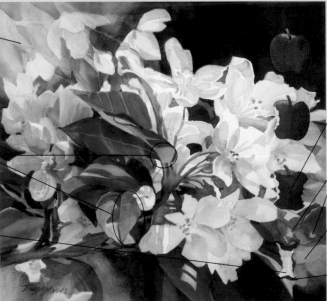

Warmer yellow (New Gamboge) is added here to balance the warmth of the apples on the right.

Here I warmed up a few leaves with New Gamboge.

I touched the bottom apple core with a bit of yellow to warm it up.

The center apples were too orangey-red. I wet them and blotted them several times to remove the orange tint, then painted them with a cool Quinacridone Rose.

Two highlights here were painted green. They interfered with identifying the white apple core.

The blossom in the lower right corner needed to be darkened. It was too light and too high contrast against the navy to be in that position.

I made the red area on the apple core larger. To do this, I needed to cut a stencil and scrub the area first.

THE CORE OF IT : *15" × 16" (38cm × 41cm)*

It is not easy to think of red as a cool color, but when overused, some shades of it can become cold and downright nasty. Perhaps you're like me and have become enamored with the Quinacridone reds. After a while, all of my warm paintings began to reek of this cool pink. Have yours?

These colors can and should be warmed up and slightly neutralized at times. This will give you more variety in your reds and make them less harsh. A wash of Burnt Sienna warms up cool rose colors and Alizarin Crimson. We come to depend on certain colors, and Alizarin Crimson (now Alizarin Crimson Permanent) has been a staple on my palette since the beginning.

After a while, many of my paintings looked alike. Quinacridone Rose then became a nice addition to my repertoire, but it too began to dominate certain types of paintings. Both of these reds are cool. A gutsy wash of Burnt Sienna is a successful, different way of warming up and controlling these colors.

▲ Too Much Pink
This cool, pink zinnia dominated a painting that I wanted to shout RED.

◄ Adding Interest with Glazes
By glazing over the pink areas with thin coats of various warm colors, the flower warmed up and became more interesting.

Because of their opacity, I always save the Cadmium colors for my last layers. This avoids making mud.

1 New Gamboge (Winsor & Newton)
2 Cadmium Orange (M. Graham)
3 Burnt Sienna (Winsor & Newton)
4 Napthol Red (M. Graham)

The Finished Product
The formerly cool, pink zinnia now shouts RED, exactly as I wanted.

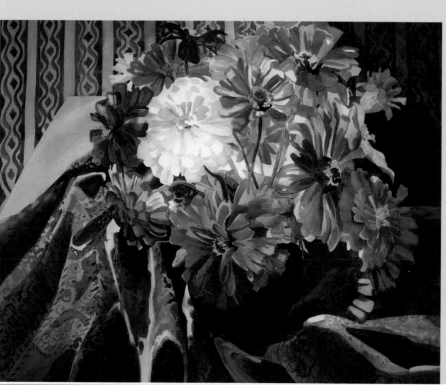

SIGNS OF AUGUST : 22" × 30" (56cm × 76cm)

COMPARE, COMPARE, COMPARE

Finally, you need to compare your painting to other strong, quality paintings. Put it next to a reproduction that you admire. Buy a gutsy painting that you love, and compare whatever you do to it. Take your painting to an exhibition in the off-hours and compare it to those that got in and those that won prizes. Then go home and make whatever adjustments are needed to make your piece exceptional.

Keep This Painting
You need to live with your new painting for a while. Don't frame it immediately. You need to glance at it, evaluate it and tweak it now and then. You have worked hard to accomplish this piece. You have a wonderful painting. Use it to compare your next paintings to! Don't sell it yet.

The Finishing Touches
Signing your painting should be easy, but it's problematic for some people. Usually paintings are signed in the lower right corner. If you have some important element there, you will need to find another spot. But be sure that your signature will show when the piece is matted. Next, practice signing your name with a small brush, like a no. 2, on some scrap paper.

Load the brush with paint, then dab it on a paper towel to remove any excess. Sign your painting, but be ready to blot it with a tissue. You may get a blob of paint at the beginning—blot it up. If the whole signature comes out way too dark, blot it gently with a smooth tissue. Lay the tissue over your signature and gently run your finger over the area. Remember, this will dry 20 percent lighter than it is when wet. Now try signing your painting.

When I am finally finished, I iron paintings that are done on 140-lb. (300gsm) paper to flatten them. To do this, preheat your iron to the cotton setting (after all, good watercolor paper is made out of cotton). Protect your ironing board with a piece of paper. Turn the painting painted-side-down, then mist the back with water from a spray bottle. Now just iron the painting for a lovely flat painting.

TELL ME ABOUT YOUR ART : *Watercolor and colored gesso : 22" × 15" (56cm × 38cm)*

HOW'S THE WINE? : *Watercolor and colored gesso : 22" × 15" (56cm × 38cm)*

Paint for Yourself
As an art critic, I interviewed this very nervous, young artist, and was inspired to begin a new series, "Artists and Patrons." The first painting was *Tell Me About Your Art* (left). As the series progressed, each new painting was compared to this one. Did the new painting emphasize both the hands and the angles that define this work? Was there a definite color strategy? Since I wanted to leave the bottom of each painting white, was the background of each work complex enough to hold my interest?

How's the Wine? (right) is a later painting that I felt compared well to the first in the series. This Chicago art patron was more interested in the food and wine than the art.

WHAT JUDGES ARE LOOKING FOR

Judging shows can be subjective; judges who choose a painting because they "like it" are accused of choosing work based on their personal taste. While this is often considered a bad thing, there are solid reasons to support some subjectivity in judging. We are trying to create solid, thoughtful paintings—ones that will surprise a judge and make him or her stop and think about them, and perhaps admire them. Ideas, surprises and content are subjective activities, so subjectivity in judging art has its place.

Objective judging is the flip side of the coin. Here a judge will analyze a painting according to the design "rules" that we have been discussing in this book. He or she will also judge your technical expertise and the originality of your technique. As you can see, this is a dry way to evaluate something that you have put your heart and soul into. Consequently, paintings need to be judged both subjectively and objectively.

Study this duality. Collect judges' statements and look for common threads in what they consider important. If you enter exhibitions, comb through the exhibition literature and see if the judge has indicated what he or she looks for in paintings. Read reviews of all kinds of art shows in newspapers and magazines. Try to figure out what the reviewer was looking for in the show. Keep a file of these statements and reviews. They will become part of your bank of knowledge.

Once you feel that you know what a judge is looking for, resist the temptation to paint for that judge. Paint for yourself. You are unique. You will create unique, authoritative paintings. The judge will feel this and appreciate it.

JUDGES' CRITERIA for EXHIBITION PAINTINGS

Looking through my file of judges' statements, I find these common threads and themes in them. They are listed in order of importance. Photocopy this list and use it to start your file. Then check other books you own and see if they have similar lists. Photocopy them too.

1. The work must have something to say. It needs to express an idea and tell something about the artist or perhaps about the act of painting. This is called "content."

2. The work should not be a formula, a cliché or something you just cranked out. These bore knowledgeable viewers and can be dismissed very quickly by an experienced judge.

3. First and foremost, it should not look like the work of another artist. When studying with another artist, look for techniques and ideas to incorporate into your own work. Don't follow this person blindly, no matter how wonderful her paintings might be. Talk with your instructor about the intangibles of an artist's life, such as motivations, focus and work habits. You can gain as much from this type of information as from their personal techniques. And your work won't look like a clone of theirs.

4. The painting needs visual design impact to hold a viewer's attention. It is important for the judge to remember your painting among many, many others. Artists are visual people with great visual memories. Make your painting memorable through content and design and by carefully critiquing your design choices.

5. The craftsmanship/skill/technique needs to be appropriate to the painting's purpose. There is a place for both highly detailed, photorealistic techniques and freer, expressionistic or even child-like brushwork in painting. All techniques that are appropriate to your content should be honored and appreciated.

6. Framing and matting should be clean and simple. National shows usually require white or off-white mats. If your painting needs, say, a red inner mat to bring out the reds in the piece, solve the problem directly by adding more red to the painting.

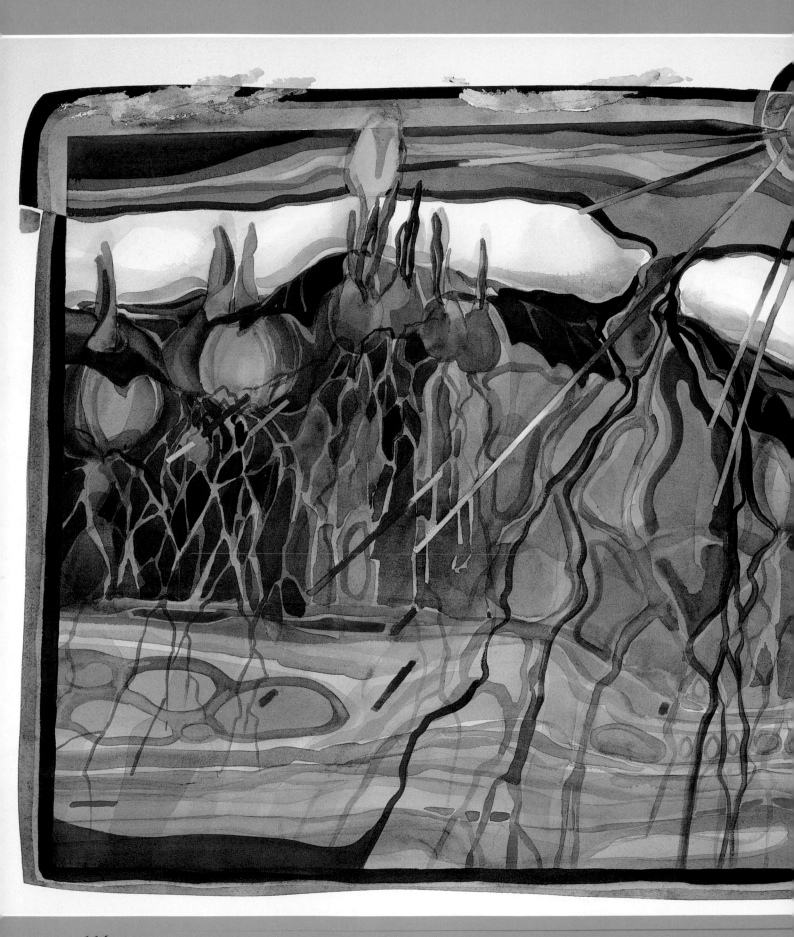

MOVE ON: IDEAS FOR GROWTH

Your painting is done! But this book and all of the others that are available are just a beginning for you in your artistic journey. I want to step into your studio for a minute and teach you how to move on. This section will show you how to become your own teacher. It will help you set yourself on a path of lifetime discovery and achievement.

As you work with the ideas in this book, your skills will improve. After finishing several paintings, you will find yourself applying these lessons earlier and earlier in your paintings. Mistakes will eventually become a thing of the past. But then the challenge is gone! It's time to move on.

Students have told me that I changed their lives. Since they no longer fear mistakes, they take bigger risks. They now test their skills on more and more daring paintings to feel this thrill. And they get into shows, perhaps for the first time—and win prizes! Now it is your turn to feel that thrill.

Here are some ideas for your continued growth. Choose one or two to work on at a time. Take them seriously. Then choose one or two more and work on those. Become your own teacher.

Creating Content and Meaning
This painting was created to give content and a depth of meaning to both floral painting and a slow spring in Buffalo, New York.

HARBINGERS : 20" × 28" (51cm × 71cm)

115

"JASPER JOHNS" IT

Jasper Johns is one of the most well-known and respected artists alive today. Throughout his long career he has continued to develop and grow. Long ago, he wrote a poem that I came across in a collection of his writings and sketches published by MoMA. Part of it goes like this:

> ...*Take an object.*
> *Do something to it.*
> *Then do something ELSE to it*
> *" " " " "*...

These lines have encouraged many artists to grow in ways they never dreamed possible. Back in 1991, I took this poem to heart, and it changed my life. The poem told me to take my favorite subject matter at that time—flowers—and push myself to do it differently. Then to push myself to take one more step. Finally, the poem pushed me to make another major change in the painting. And that step was agonizing—and thrilling.

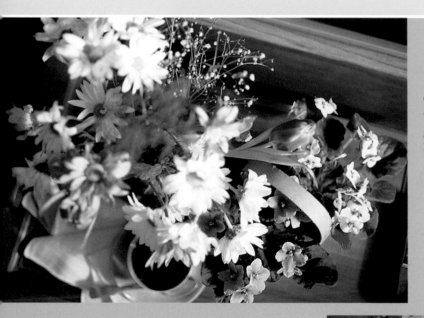

1 Take Something
The poem said that I needed to take something—I chose flowers—and do something different with them. So I decided to paint my flowers from a new point of view. Setting them up at my feet gave me a different, bird's-eye view of the flowers and cup of coffee.

2 Unspectacular Results
Here is the resulting painting... not much to write home about. How could I take this painting and change it? What would Jasper Johns do?

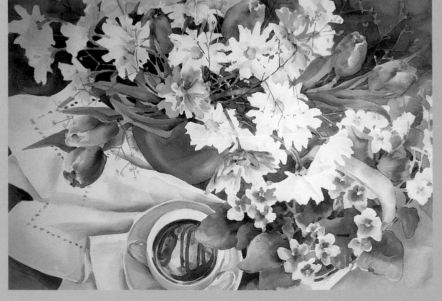

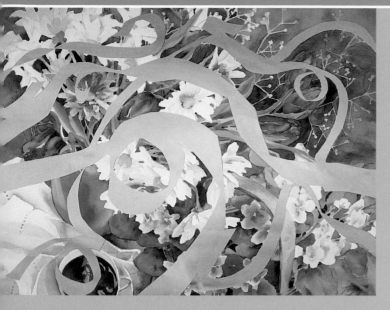

3 Do Something With It

After much thought, I repainted the piece and then plunged in. I was determined to kill or cure this second version. Finally, I decided to dump a bunch of ribbons on the floor and paint them. Then, agonizingly, I did something else with the floral. I put the ribbon painting on top of it and, with a utility knife, I cut through the two paintings along the edges of the ribbons. Piecing the two paintings together like a puzzle, I glued them on a backing board. This inlaid "puzzle" then became the subject matter for my final step—do something else with it. Much work. Much daring. Neat idea.

This new version was selected for a national show—my first. But when I went to see the exhibition, the painting looked awful! It appeared washed out and wimpy next to the powerhouse watercolors surrounding it. My neat idea was not neat enough to be competitive. The painting should have been richer and stronger.

4 Do Something ELSE With It

When I got the painting back from that show, I took it out of its frame and painted the ribbons bright orange. Then I painted three or four layers of color over the entire painting. Now I had a gutsy, well-balanced and very different floral. I saved this painting and for many years compared my new pieces to it. Is the new work as bold? As creative? If not, Jasper Johns it!

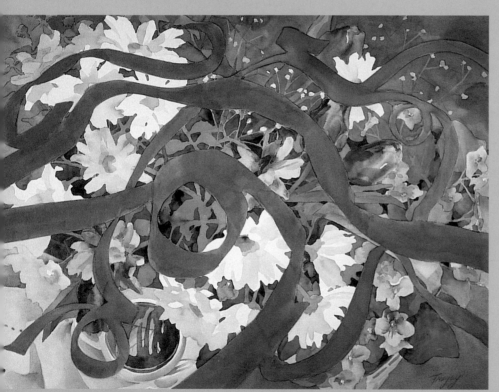

HOMAGE TO JASPER JOHNS : 22" × 30" (56cm × 76cm)

WORK IN A SERIES

A series of paintings needs to have a common thread. You, the artist, are the only one who can decide what that thread might be. It could be based on a passion of yours, or a certain style, such as abstraction. Technical aspects of painting can be the thread of a series too. Wet-on-wet painting, heavy texture or a special painting tool could become your thread. Art supplies such as ink, acrylics or specialty papers may give the series a common look.

Here are three paintings from a new series that is now eight paintings long. This lacy woods painting evolved into one with a solid, opaque foreground

hill. That painting needed a surprise, so I got daring. I embroidered three abstract flowers onto the hill—yes, with a needle and embroidery floss. Then to take this series one step further, in my next painting I went bolder with my colors, the shape of the foreground, the intensity of the pencil work and the linear abstraction of branches and shadows. My surprise of embroidered "dandelions" is still the special treat.

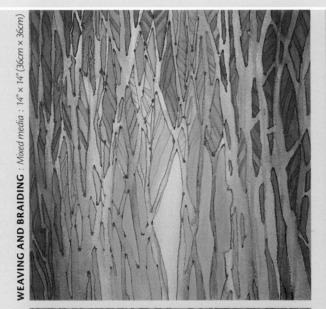

WEAVING AND BRAIDING : *Mixed media* : *14" × 14" (36cm × 36cm)*

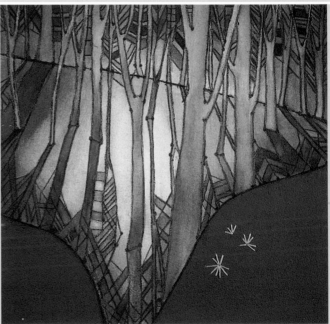

THE THIRD ACT : *Mixed media* : *14" × 14" (36cm × 36cm)*

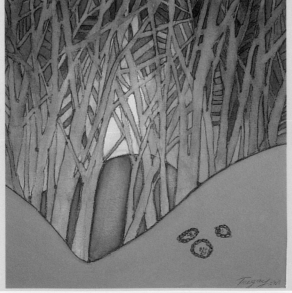

ANNUAL MEMORY : *Mixed media* : *14" × 14" (36cm × 36cm)*

Why Work in a Series?

Working in a series can help you focus on both technique and your content. When you explore a topic thoroughly, frankly, you become bored with it. Then you get bold, somewhat irrational and daringly creative! You will begin to delve deeply into all of your topic's many aspects and interpretations. How can you present this idea in a different way? What more can you say about it? By slowly adapting your style, technique and/or materials, you will conquer them and they will, eventually, contribute to your own personal look.

How Many in a Series?

You can do any number of paintings in a series, but the real advantage of working this way is the boredom factor. At about the tenth painting in your series, you'll get really bored with your subject. (You may curse me at this point for recommending a series, but I won't be around to hear you, so go right ahead.) But I guarantee you that your eleventh painting will be more creative than whatever you have done in the past—it has to be! The only way to get around the boredom of painting the same subject is experimenting with your ideas and the way you paint it. Don't give up!

Around the same time, at about the eleventh painting, you will also begin to rid yourself of the remnants of other artists' and teachers' work, and your paintings will begin to truly develop a look that only you can create. You will have found your own voice. So, how many paintings are in a series? I recommend fifteen or more.

HOW to WORK in a SERIES

Buy a new sketchbook and make this your "idea" book. Collect ideas, inspirational quotes, newspaper clippings and so on, and paste them in. Use your idea book for lists of brainstormed ideas. List all sorts of possibilities, from silly to great, and potential titles. You will use some of them later, and this way, they'll be at your fingertips when you need them.

Write in your idea book. What's happening in the world today? What is growing in your garden? This may become your journal. Whatever your interests are, they will emerge through your writing. Let these ideas simmer in your mind. Gradually, through your notes, they will become concrete and begin to develop into painting images. Is there a photo, idea or article that might inspire a future painting? Paste that on a new page and begin collecting thoughts around that topic.

When you have time to paint, first spend some time reading and reviewing your book. This will jump-start your painting. Take a photo of your most recent work. Paste that photo into your book. Evaluate these pictures for parts that you really like and could develop further. What was your original idea? How can you push it further? Build each painting on what has come before it.

A Peek at My Sketchbook

The immediacy of digital cameras makes it easy to keep my sketchbook up to date and full of ideas. Here in the upper left you see a magazine photo of a work that interested me. I analyzed it and wrote notes to myself, then did four little samples on different kinds of Crescent painting boards. The resulting painting, *View From the Backseat #4*, is photographed and glued on the right. Then I worked out a few ideas for my next painting, including leaning future paintings toward the new Pantone colors, glued on the bottom left.

Knowing how you work, and organizing yourself, can have an actual effect on your paintings.

Learn From Yourself

Lay five or six paintings on the floor. Walk around them and study them from each side. Following the steps in this book, make each one the best that you can. Then look for what you love in these paintings. Is it the topic? A particular color strategy? Or a special emphasis on line or texture, perhaps? Focus on what you have learned that you love for the next few paintings.

Do you particularly love a small area of a painting? Lay some strips of paper around the area to isolate it. Perhaps you can photograph the space, print out a copy, and then use this area for a large painting. Because backgrounds can be problematic, this area might be enlarged for the background of, say, a realistic still life. Learn from yourself.

Set Goals

"Successive approximation" is a wonderful term that I lived by when I taught elementary school: It basically means to set a goal. Some goals might be to develop a signature style, complete a series, win an award or get accepted into a national show. After setting a goal, plan small steps that will bring you closer to it. When you get near your goal, you may find that your idea has been refined and your goal slightly altered. That's OK. Redirect your path slightly and keep on working. Successive approximation.

Record Your Work

Use your series sketchbook as a depository for all of the information about each painting. Was it inspired by other work? Paste a photo of that work in your book. Was it influenced by something you read in the newspaper or a cartoon? Cut that out and paste it in. (Glue sticks are wonderful for this.) Include the date your painting was finished, its size, medium, paper, title, shows it was in, prizes, whom it sold to and for how much and so on. Fifty years from now museum curators will love you for this information.

Manage Your Time

For most of us, good time management comes from good self-esteem. You are doing valuable work that is both financially and personally rewarding. Laundry, housework and grocery shopping are secondary concerns. Do these on the weekends when everyone is around to see you do it. That way, they'll learn that this work isn't done by elves.

Buy yourself a timer for your studio, and use it. Set it for an hour or two and don't let yourself leave until it rings. If you enjoy working to music, make yourself work until a CD or two has finished playing. Keep a calendar of how many hours you spend working on art each day. Reading and thinking about art are equally as important as painting time, so count this time too. Write down on your calendar when you finish a painting and put a box around it. When you sell a painting, put a colored box around it. Save your calendars from year to year in a folder. Mine date back to 1987.

Simple Tools for Time Management

LOOK FOR A BALANCE

Find a balance between your creative works aimed at exhibition and your more decorative, sales-orientated paintings. I spend the winters working on exhibition paintings. Summers are usually devoted to painting to please others. In this way, I have come to look forward to winters. And when I return to more decorative painting, I am always a much better painter.

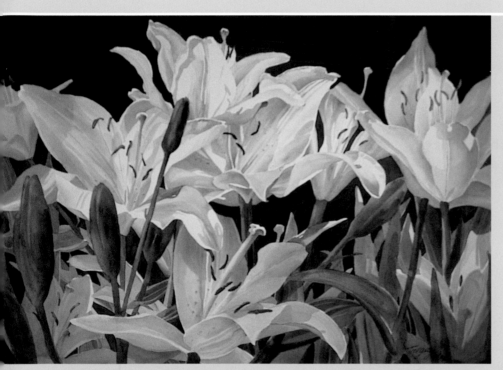

Sales-Oriented Work
As outstanding photos accumulate over the course of the year, I can choose the best of the best to work into paintings. But as much as I love my garden and enjoy painting florals, when these paintings became my bread and butter sales, I needed to force my personal work to grow in other directions.

LILIES GALORE : *22" × 30" (56cm × 76cm)*

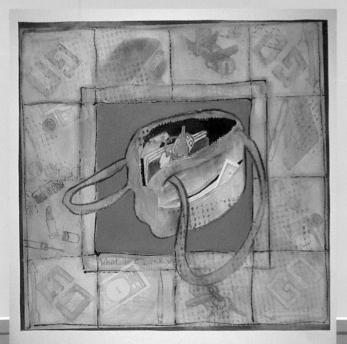

Personal, Exhibition-Oriented Work
Over the years I have often addressed women's issues in my paintings. Here, an over-filled purse became a metaphor for our burdens. This purse belongs to an artist/realtor friend of mine, so I placed it on a Monopoly game board. Joan is always busy, so I wrote the command "go" in all four corners of the board.

WHAT WE CARRY : *Mixed media : 20" × 20" (51cm × 51cm)*

Write an Artist's Statement

Part of our struggle and goal as artists is to remain focused and committed to working in our series. So at this point in my workshops, I ask the participants to write an artist's statement. They all blanch in terror at the idea. But these are easy to write and nothing to fear.

Long ago, I went through a wonderful magazine called *New American Paintings*. In this magazine, each artist supplies an artist's statement along with his or her resume. I wrote down the first phrase and the second phrase of each statement and made the two-column list on this page. Choose one phrase from each column and start your statement with these. Then continue on to write two or three sentences about your art. Copy it into your sketchbook. Do this every now and then, and your thoughts and your work will become focused.

Artist's Statements

I would like to share a few artist's statements written at the end of one of my workshops with the Asociacion de Acuarelistas de Puerto Rico:

I began my current body of work because of my love for history and archeology. It embodies moments in my imagination of what life was like hundreds of years ago.

—Daly

My work explores seascapes. I draw them in a way to suggest an escape from everyday life. —Susan

Painting is my love. I find when I'm painting I relax and my spirit soars. So for me it is more like a spiritual experience, and I give thanks to God for letting me have such an experience while being a young girl. —Lucky

What I paint could convey strong feelings of beauty, happiness, sadness, ugliness or anger. They are so intense when I express myself in my art. When restless, I regain my peace by painting. I am my paintings. —Arelis

I think of a work of art as a personal experience. I admire my friends here who have transcended that and make art a way of life. I started painting when I was well into my mission of mother/homemaker and struggled to make pockets for other endeavors outside the house, like painting with the Acuarelistas. I am thankful, however, because I consider my way of life a kind of art also.

—Carmen

Is your life a work of art? Write about it. Paint about it. When you can take your art into a personal realm—and this is very difficult—you are on you way to creating museum-quality fine art. You can do it. We all can.

MIX AND MATCH Phrases to START Your Artist's Statement

Choose one phrase from each column and continue your statement from there.

At the heart of my work is a desire to	The impetus for my work
During the past several years, my art has	My paintings reflect
My paintings are about	My goal as a painter
I first began	This series of paintings
Several years ago, I was looking through	My work explores
My conceptions originate	As a painter I try to
I think of works of art as	I can't paint these days without feeling
I take ordinary things	It has been said that
I began my current body of work	using

You are now headed for uncharted territories—the world of content as well as the goal of competitive, finished paintings. You are entering a maze, of sorts, complete with dead ends and hidden passages. You are entering a dialogue with yourself as well as with the greater art world. Don't fear ironic endings. This journey never ends.

FEAR OF IRONIC ENDINGS : *Mixed media : 15" × 22" (38cm × 56cm)*

realized

in contradiction

communication

personal experience

embody moments

a sense of

carve out a

focused on

shifting

conveys

continue to influence

is to explore

was an attempt to

and draw them in a way to suggest

with a simple question

moves beyond

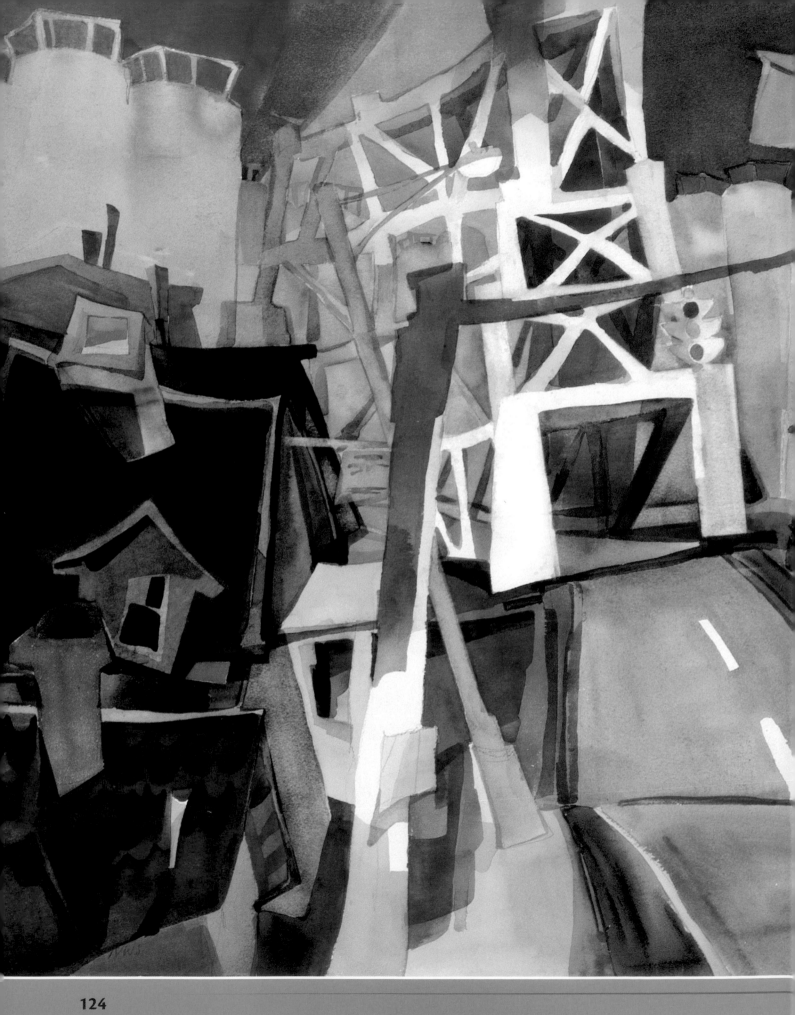

CONCLUSION

As you finish your painting and finish this book, know that you are on a path, a highway, traveling far and fast. This artistic journey will never be finished, but it will move you. As you finish one painting, another idea will challenge you. And yet another is just around the corner, waiting.

I hope this book has emboldened you to jump heedlessly into the flight of fancy that is painting. Are you fearless now that you know how to change and correct things? Are you discontented with boring backgrounds? Have I empowered you to paint gutsy, juicy colors? Are you confident that you understand how to unify your work through color and design strategies? Are you ready for some fun? Ready to surprise us? Then you have absorbed the lessons in this book.

As with any workshop or book, I have presented an overwhelming amount of information here. Work your way through these five steps each time you do a painting. Eventually, some of the steps will come naturally. Even now, I list them to myself when I am nearing a painting's completion.

For now, you will need to refer to this book continually. Wear it out. Break its spine. Use *Master Disaster* for your scrapbook and notebook. It will become precious to you and totally indispensable. Now, write these words on your wall and take them to heart: No more wimpy watercolors! Kill it or cure it!

Plan your artistic journey, but adjust your itinerary when you need to. Explore a few back roads—but not too many. Continue your trip, and let me know where your travels take you.

THE TRIP : 22" × 30" (56cm × 76cm)

INDEX